Studies in Mixed Media

Figures and Designs for the Month of April 2013

By Benjamin Long.

Illustrations by Benjamin Long for the Month of April. New Illustrations and commission work that was requested of me. Many pieces feature the cartoon/ cross hatch style that I have been working on as well as a few underpaints.

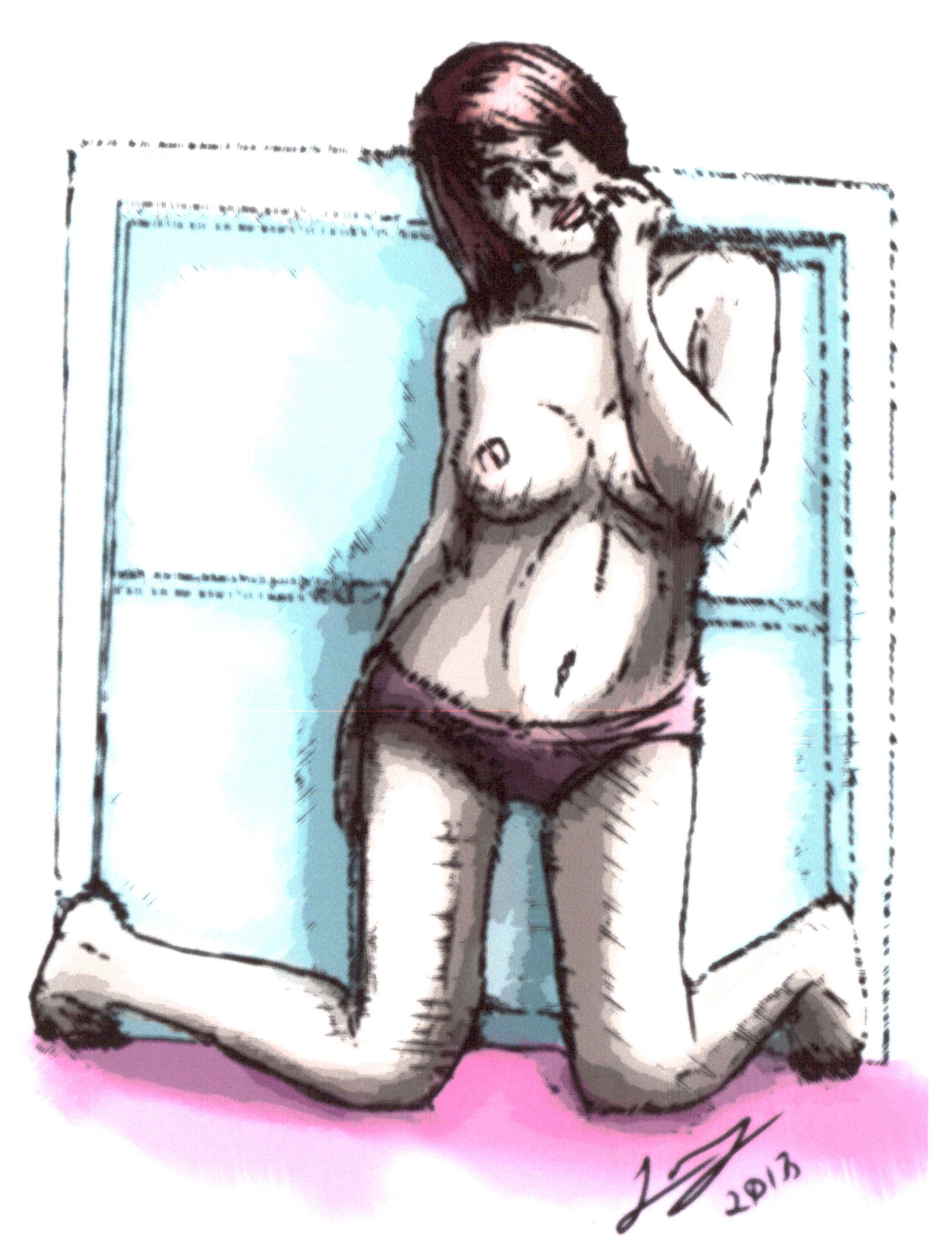

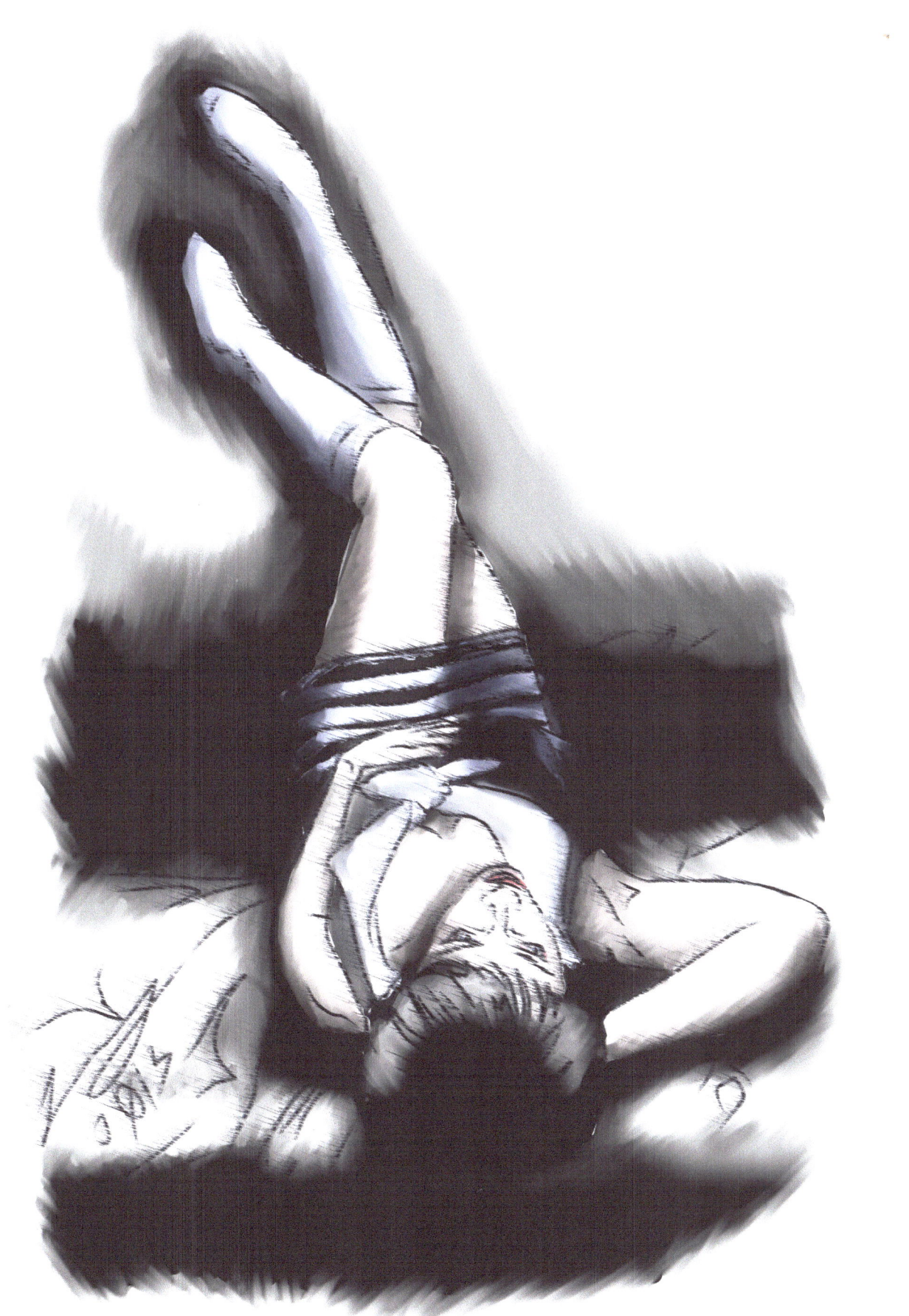

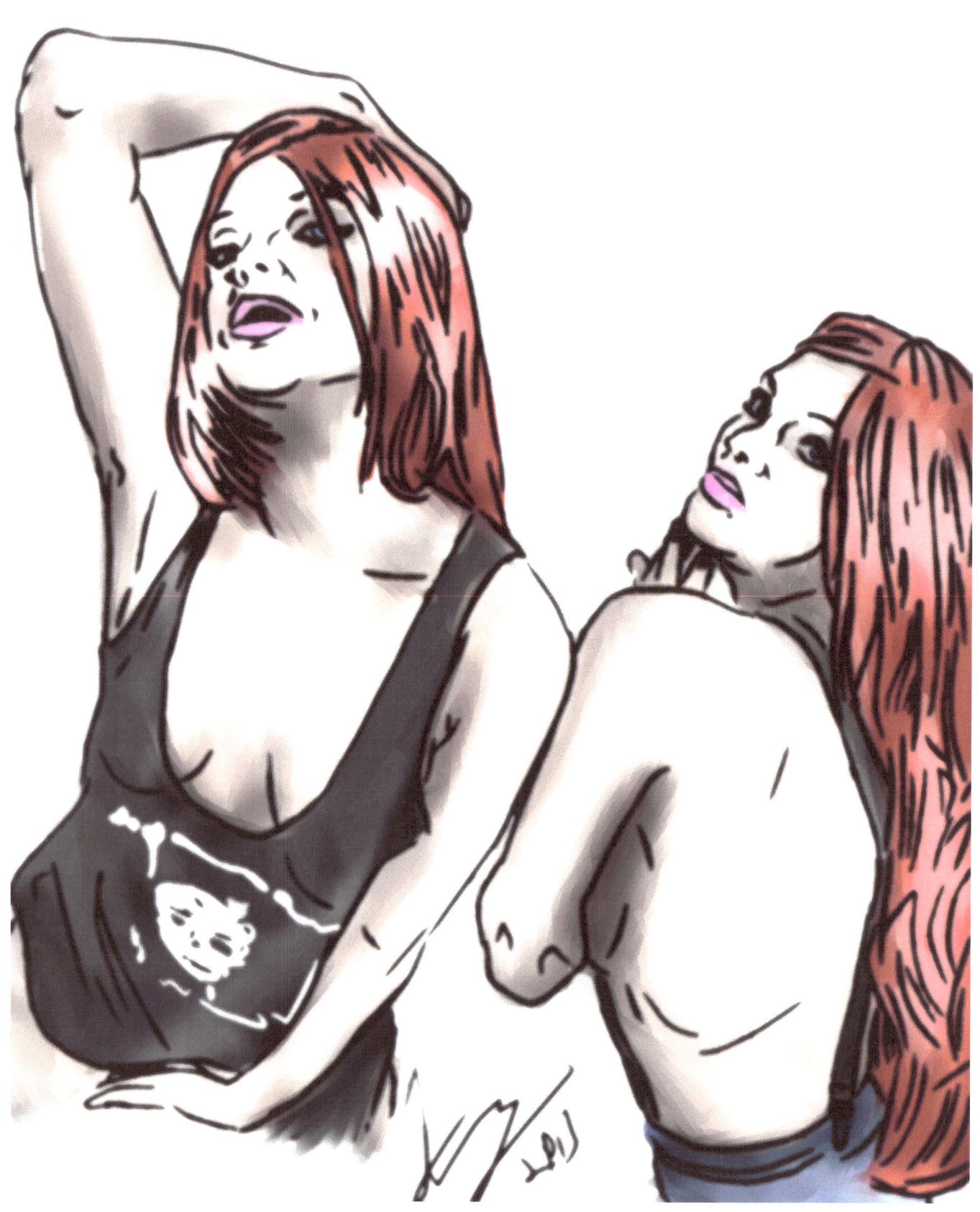

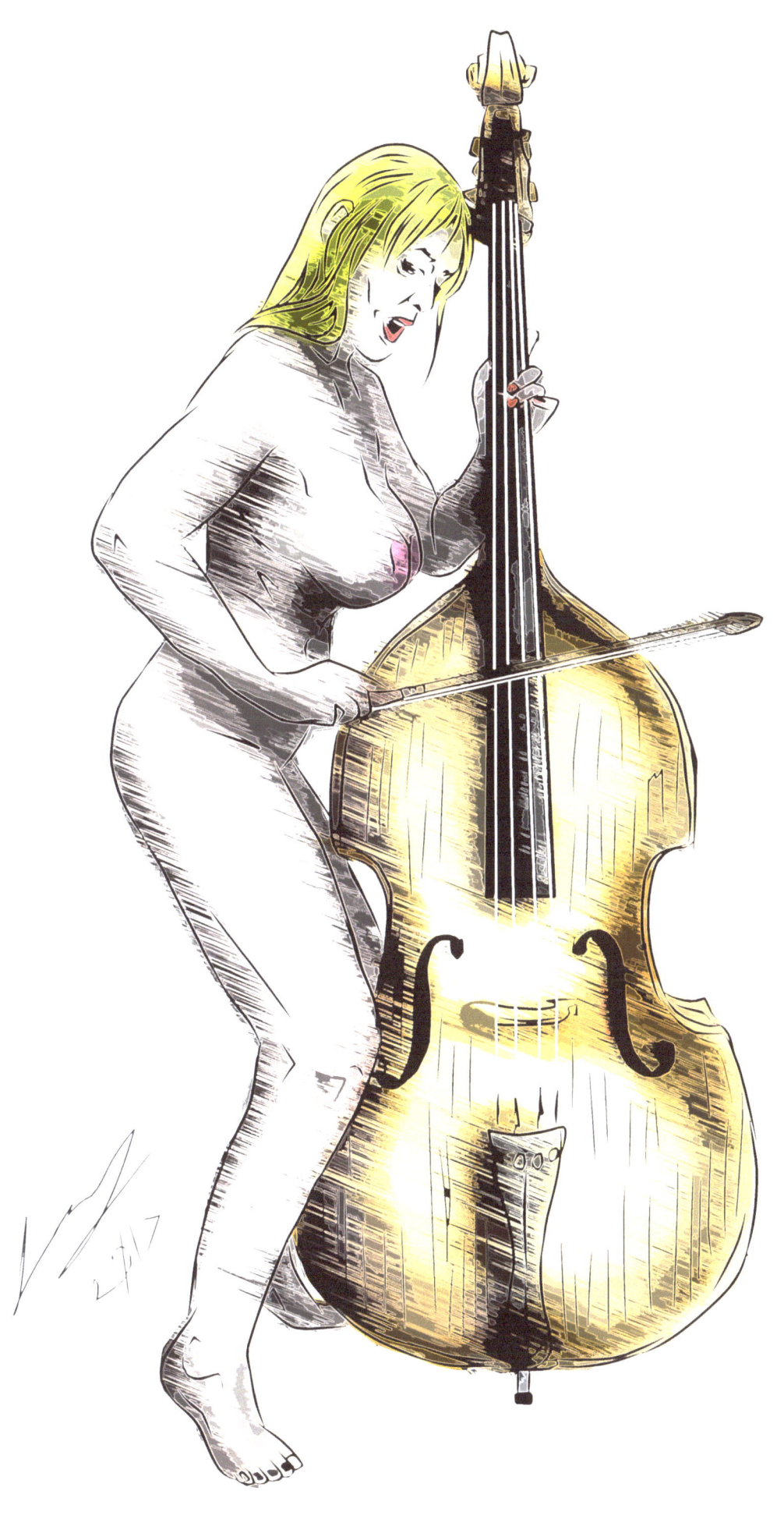

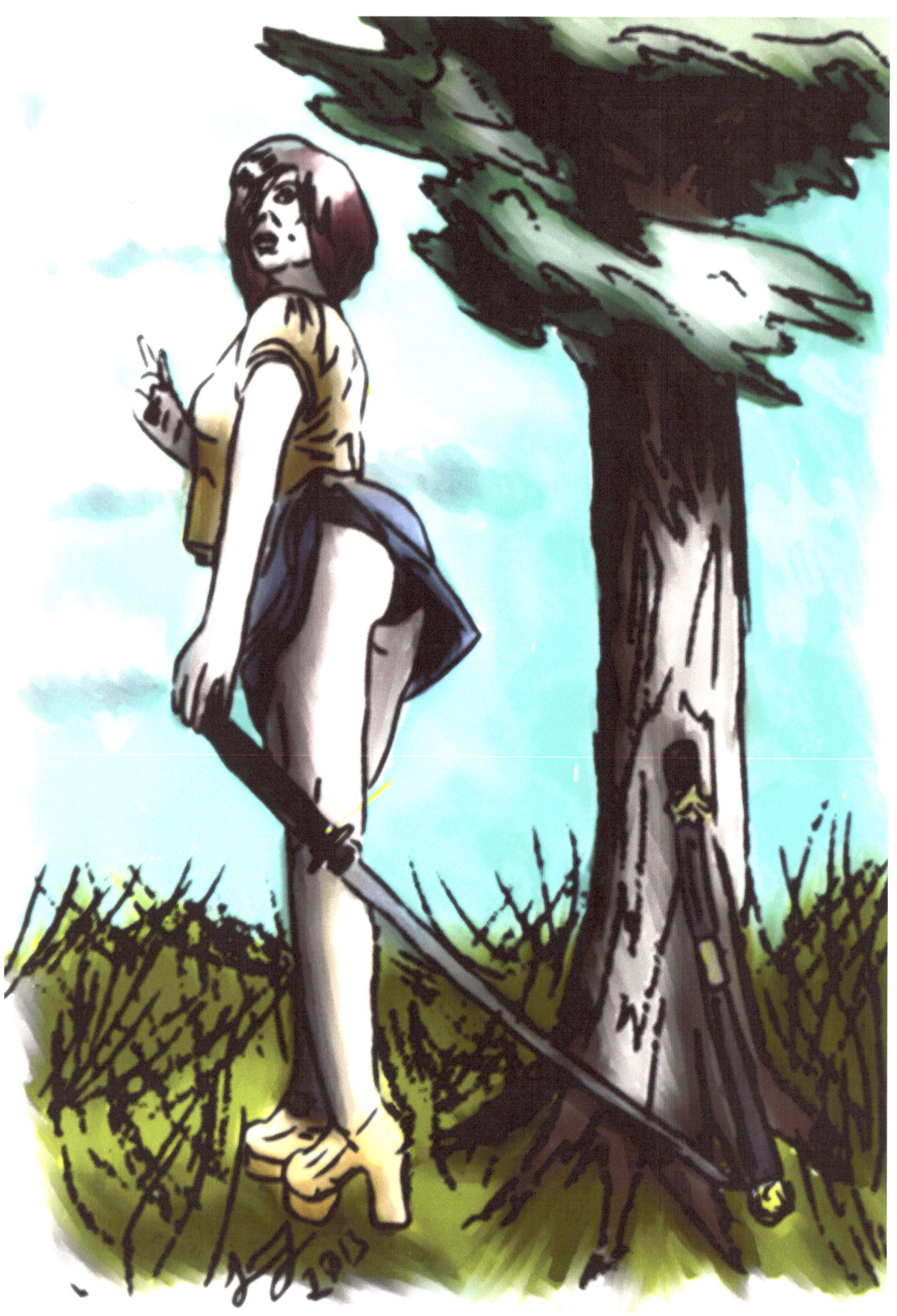

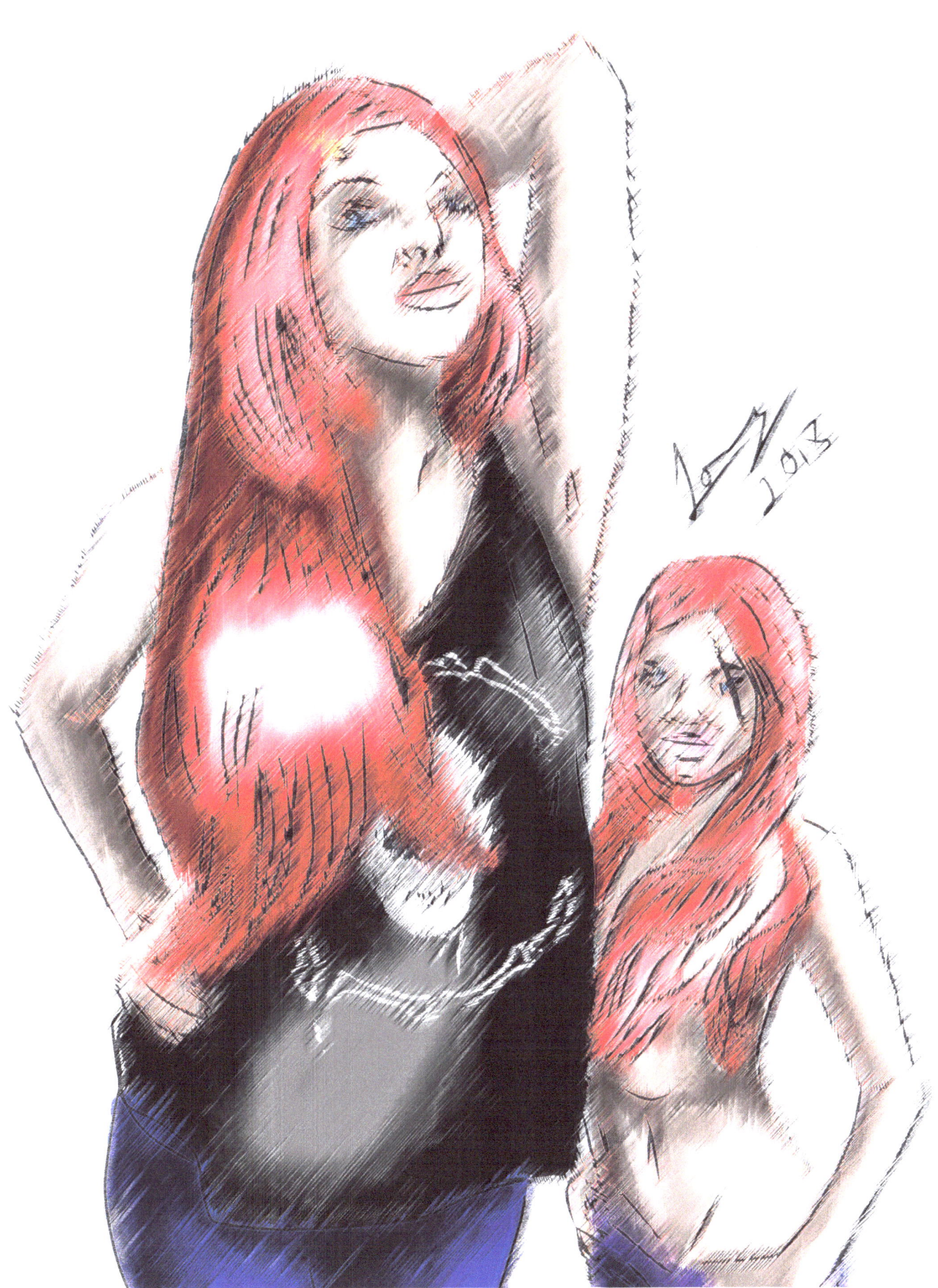

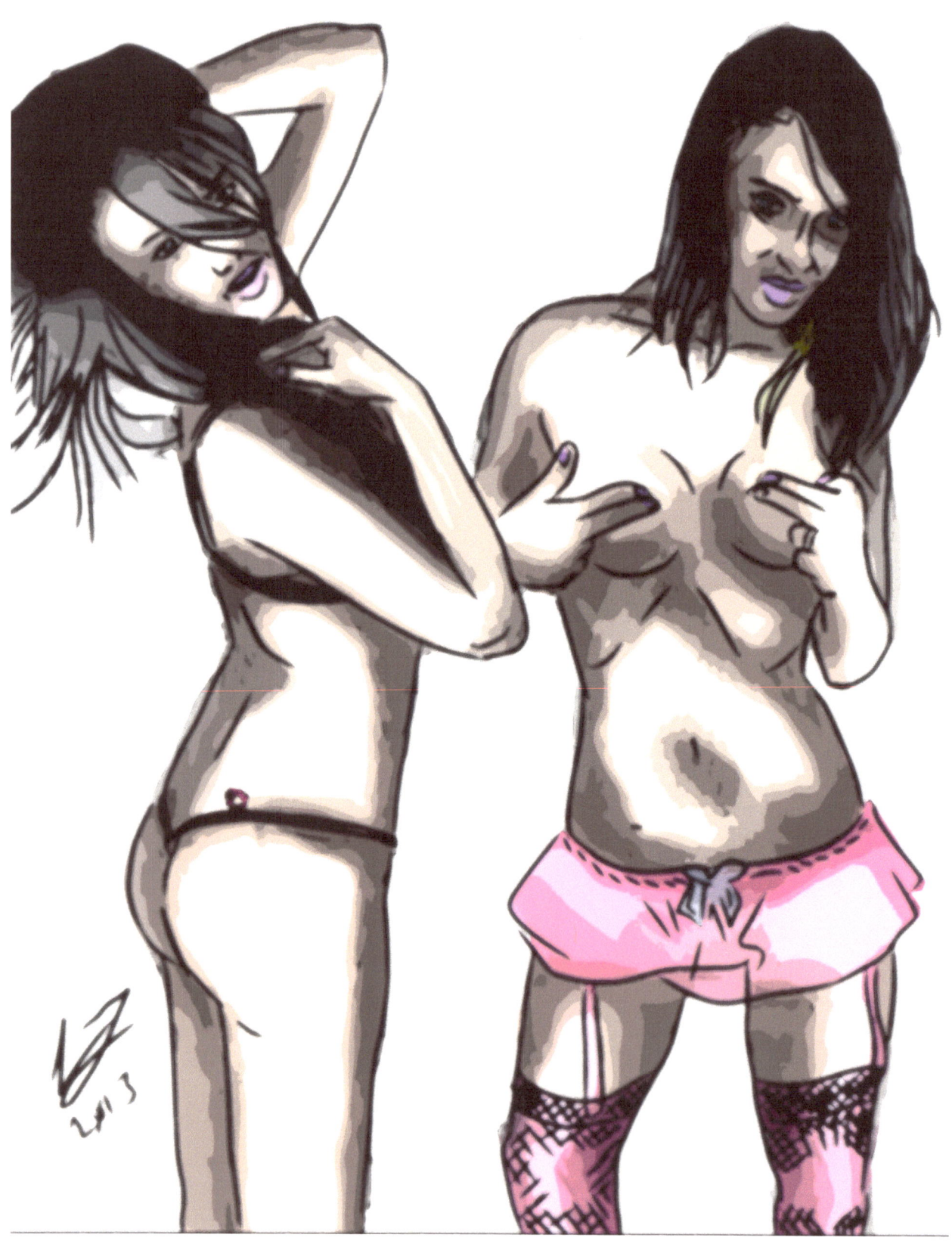

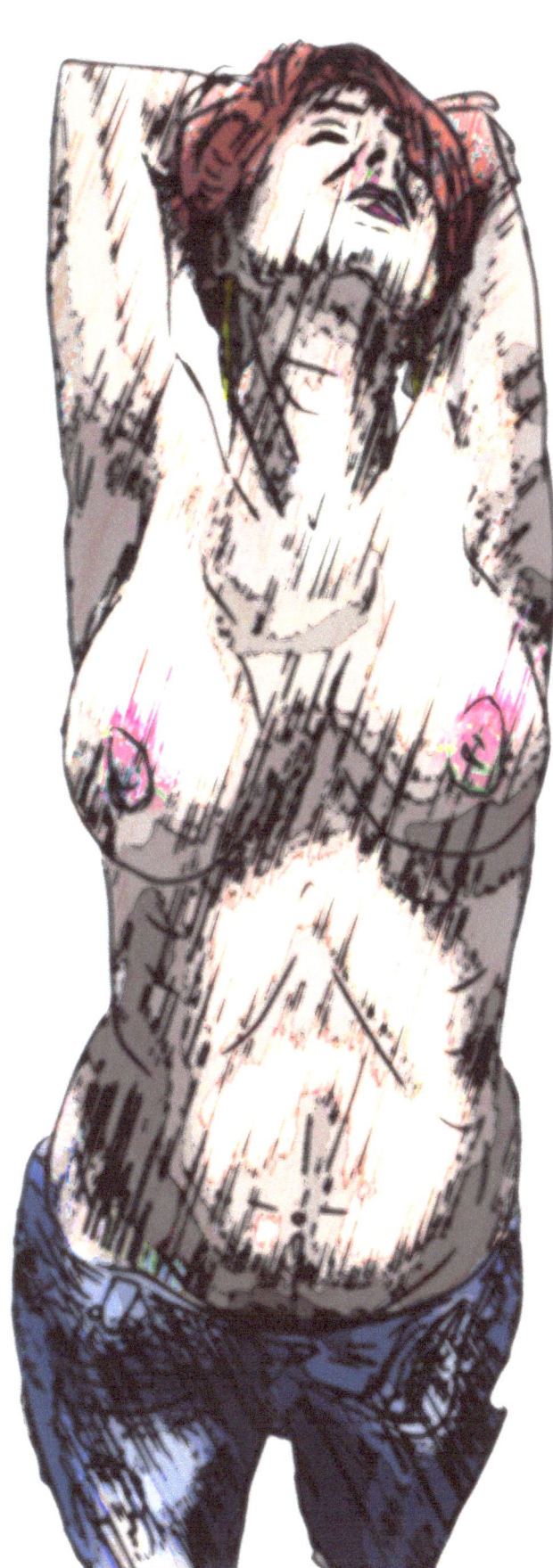

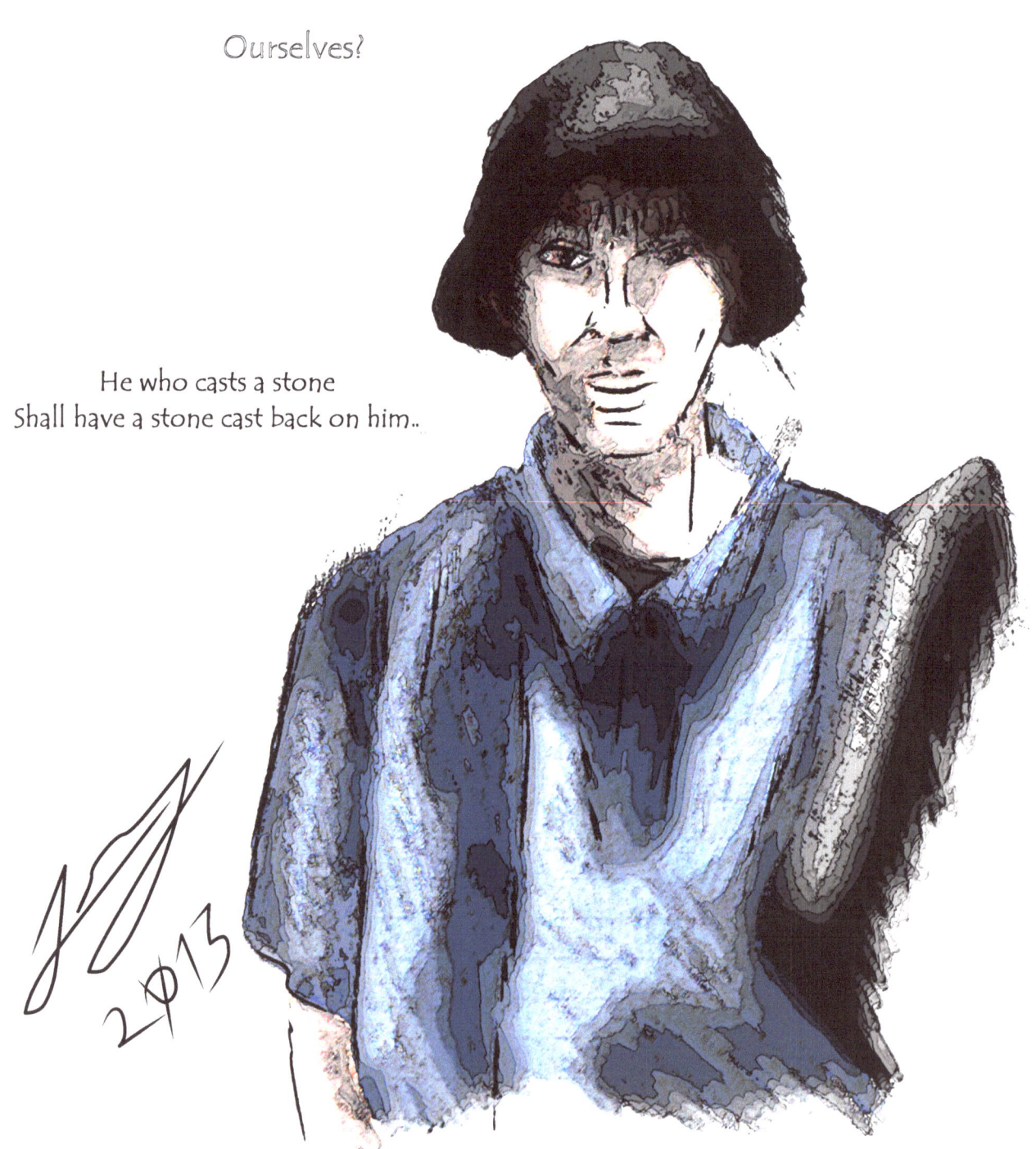

You say that Video Games are to blame...
You say that Guns are to blame...
You say that aliens, and grand government conspiracies are to blame...

In all this effort to cast blame
Have we forgotten the sole blame

Ourselves?

He who casts a stone
Shall have a stone cast back on him..

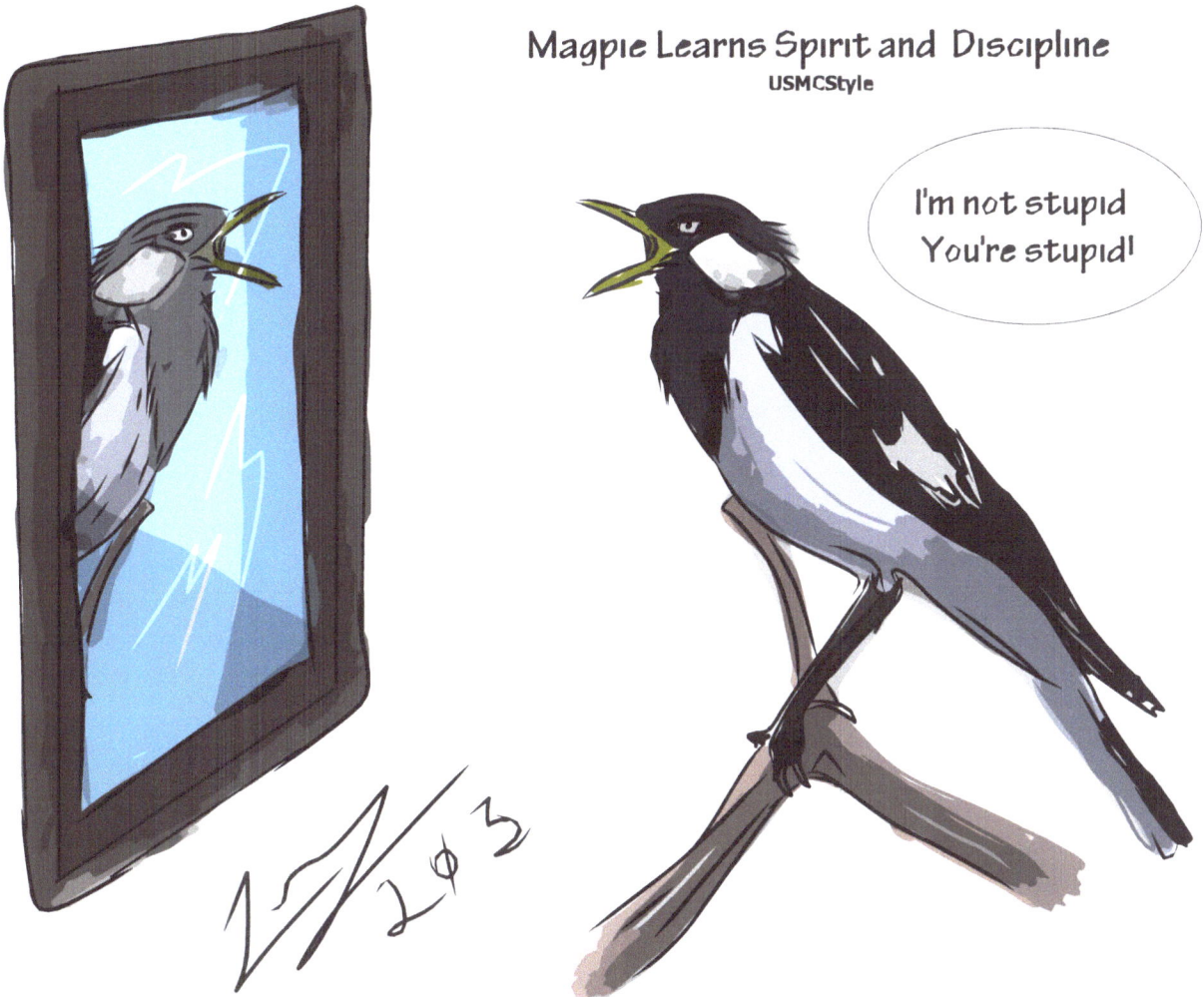

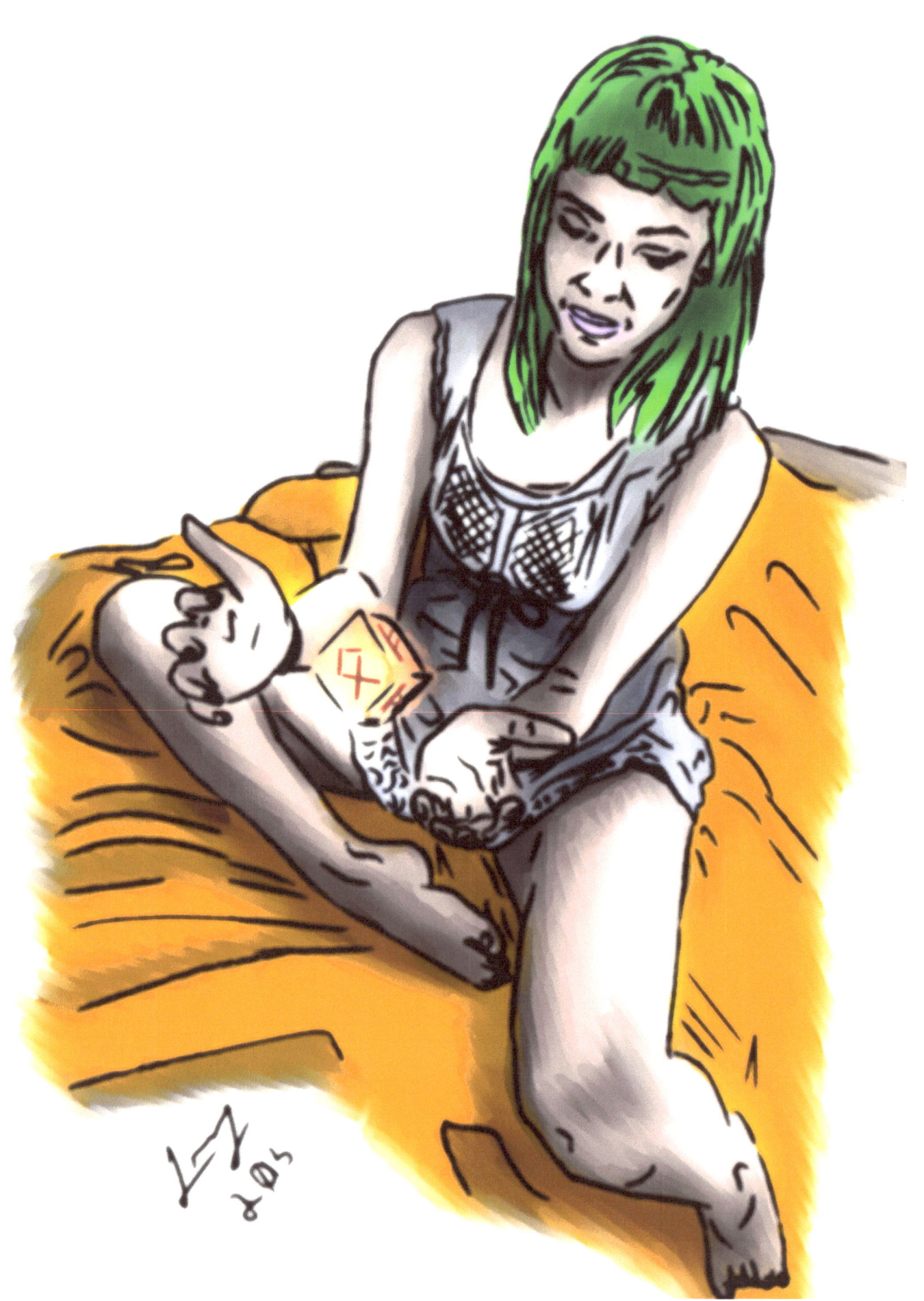

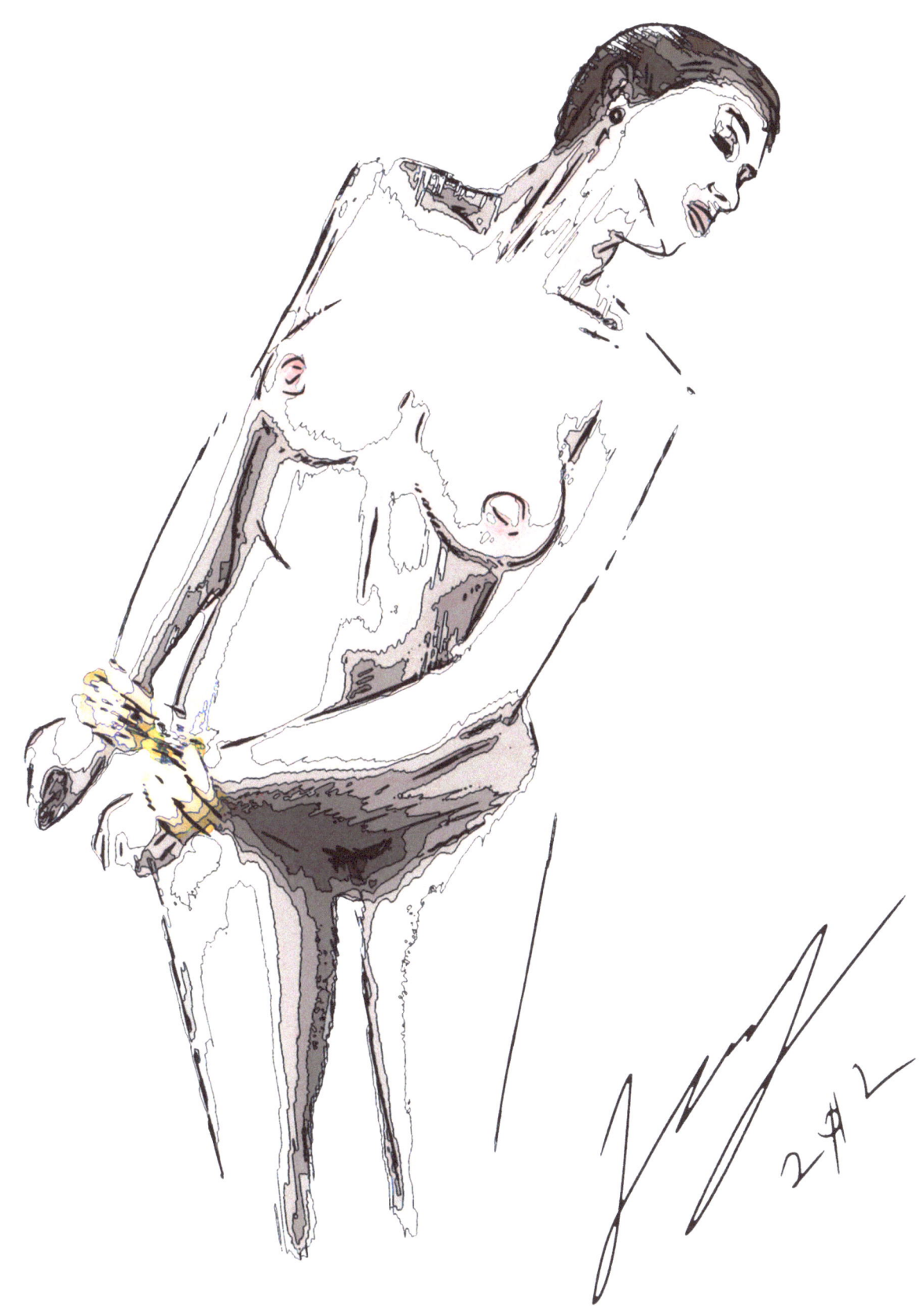

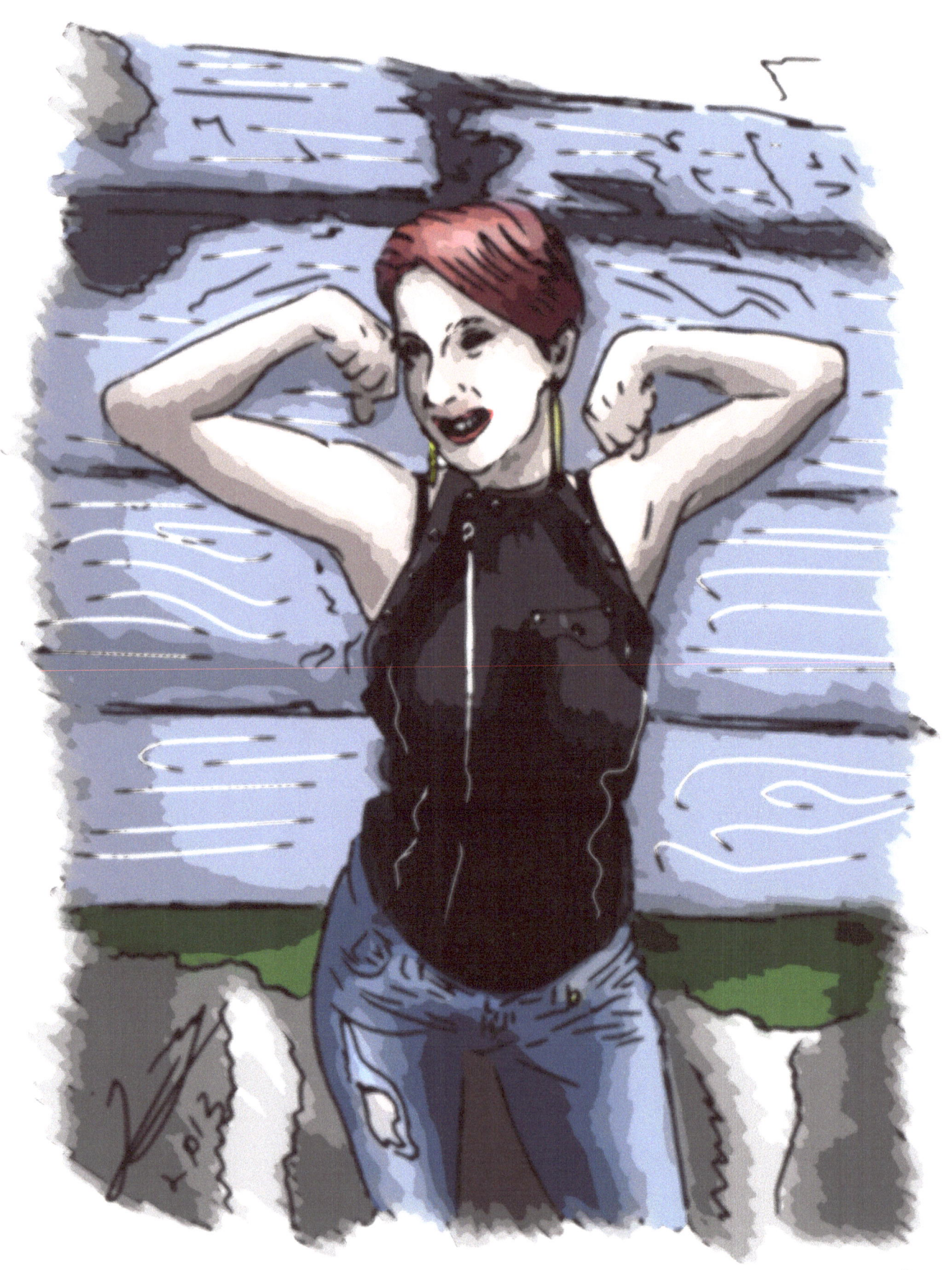

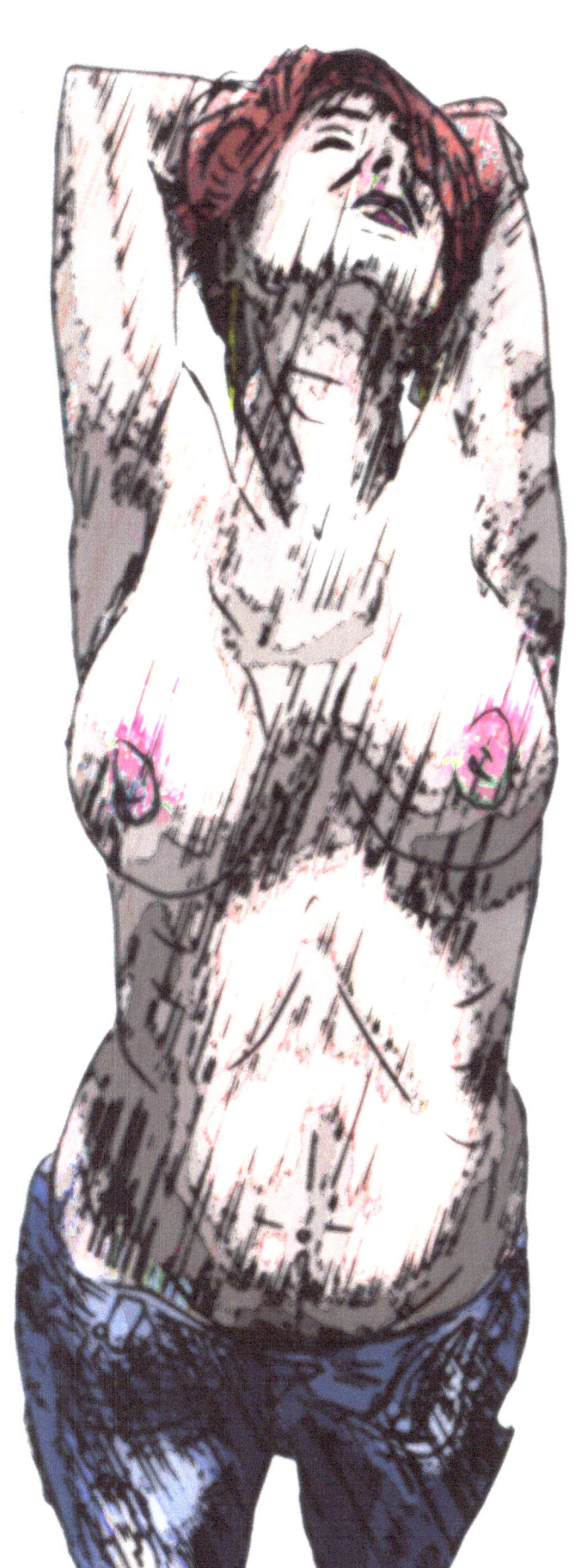

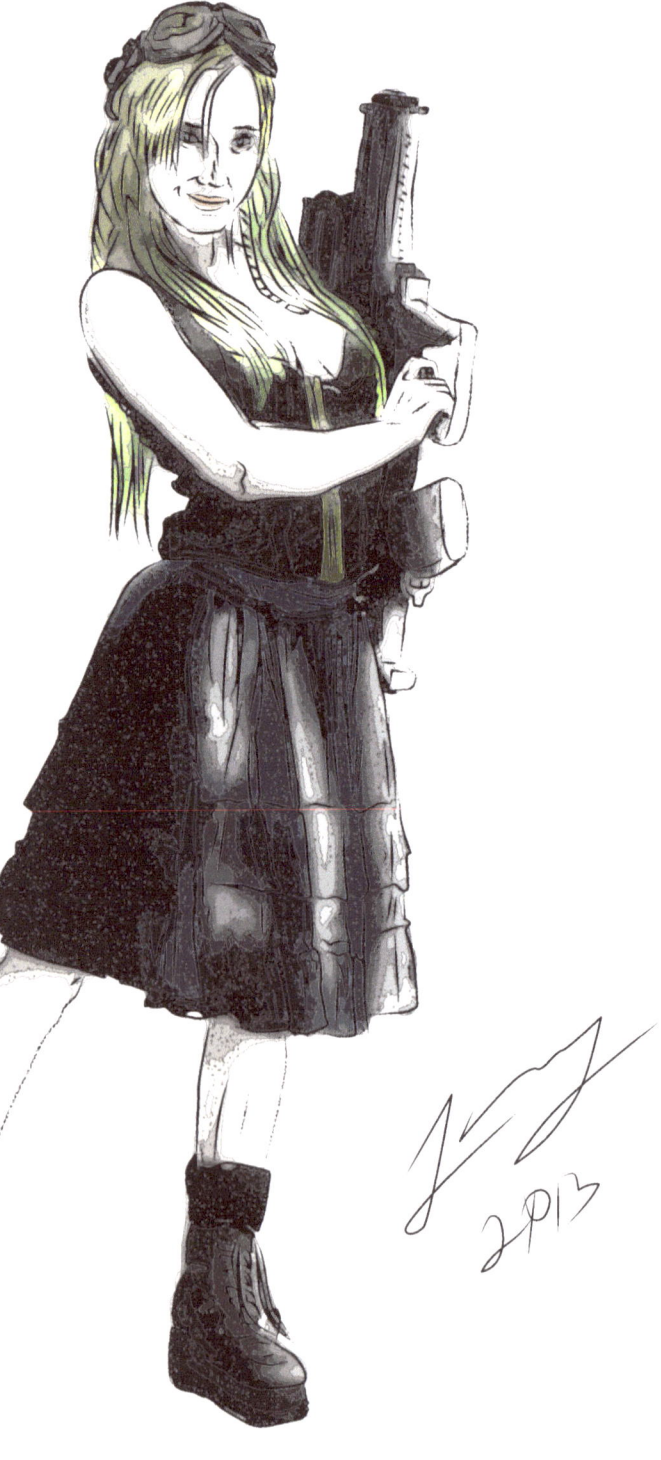

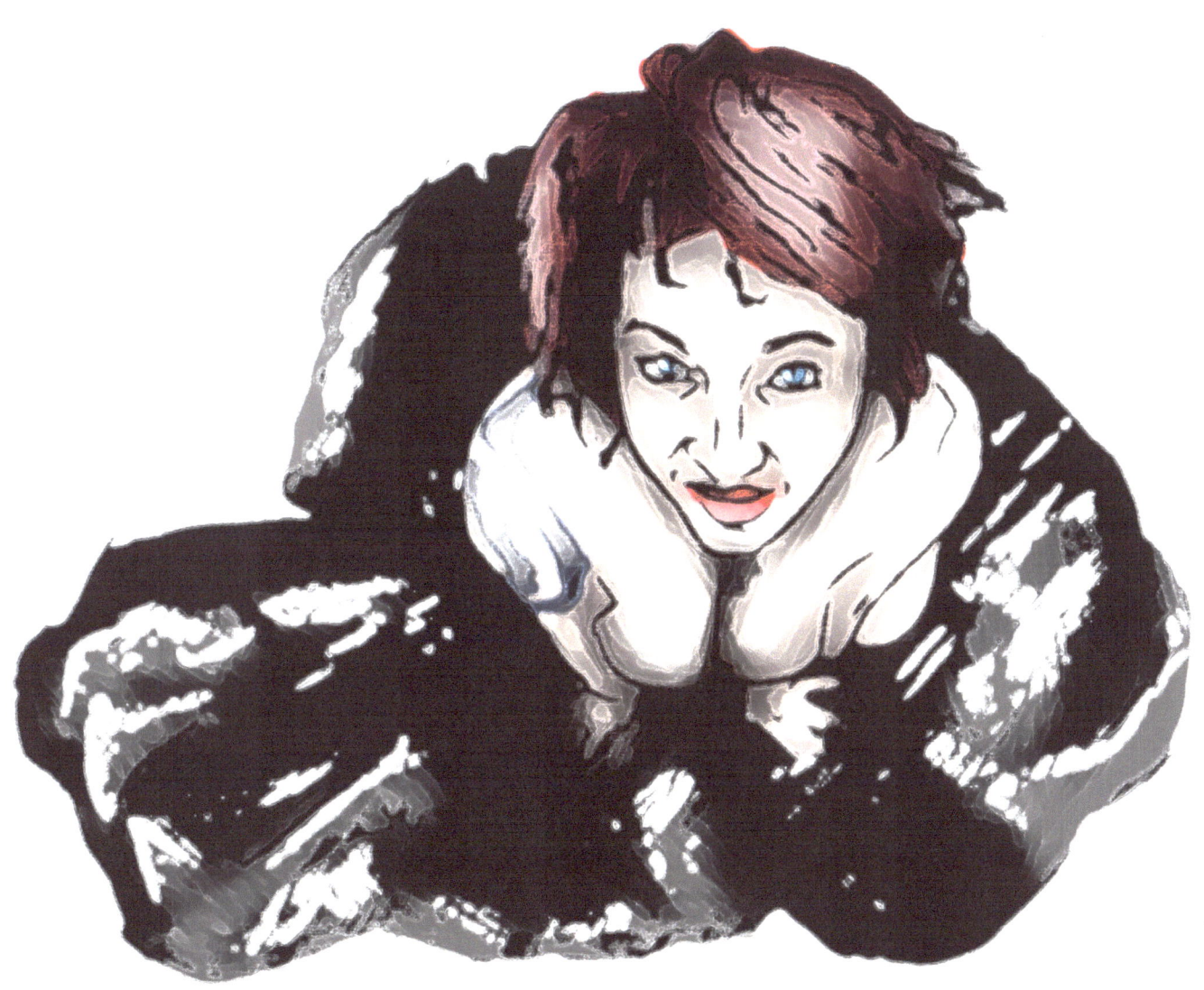

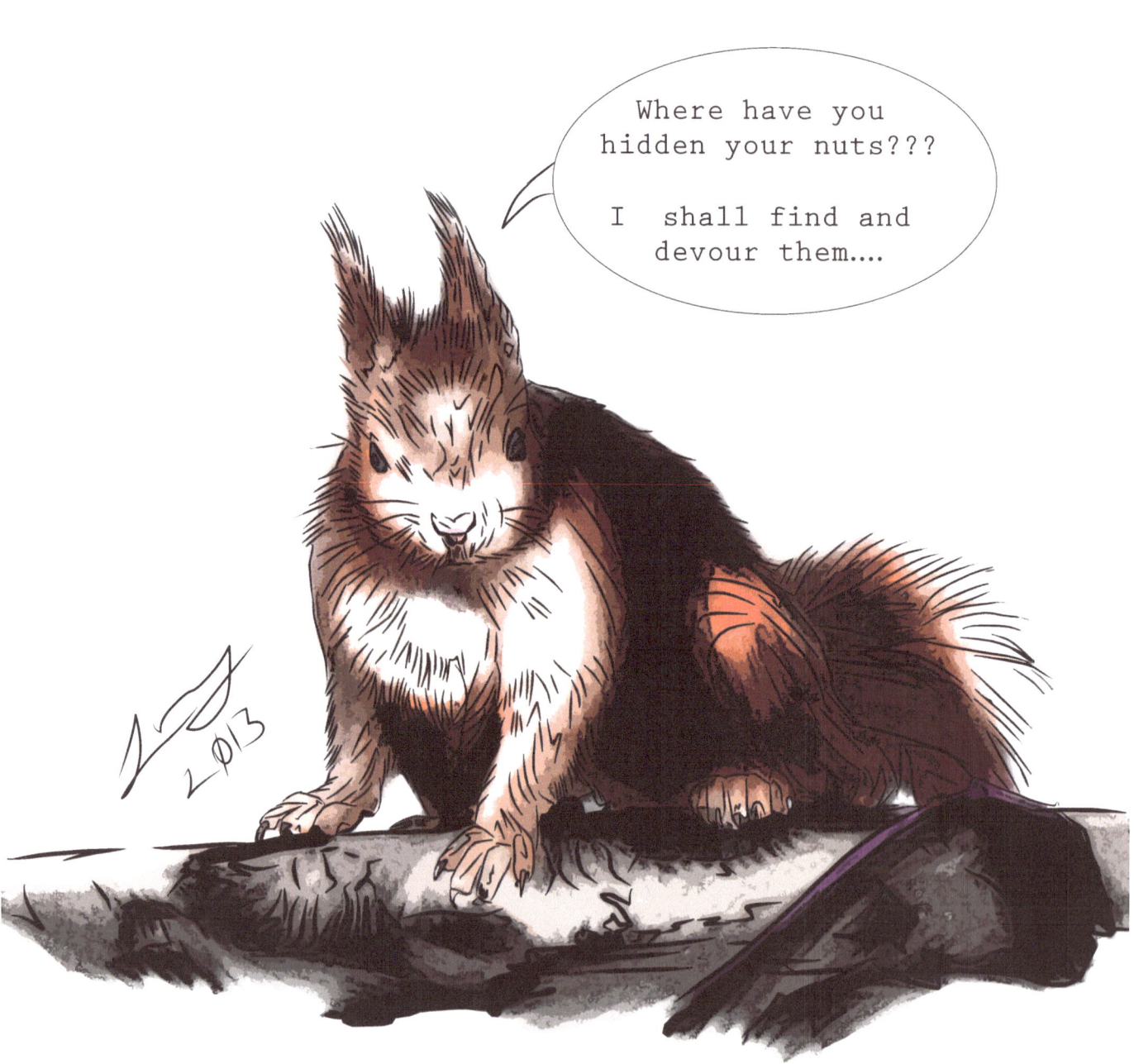

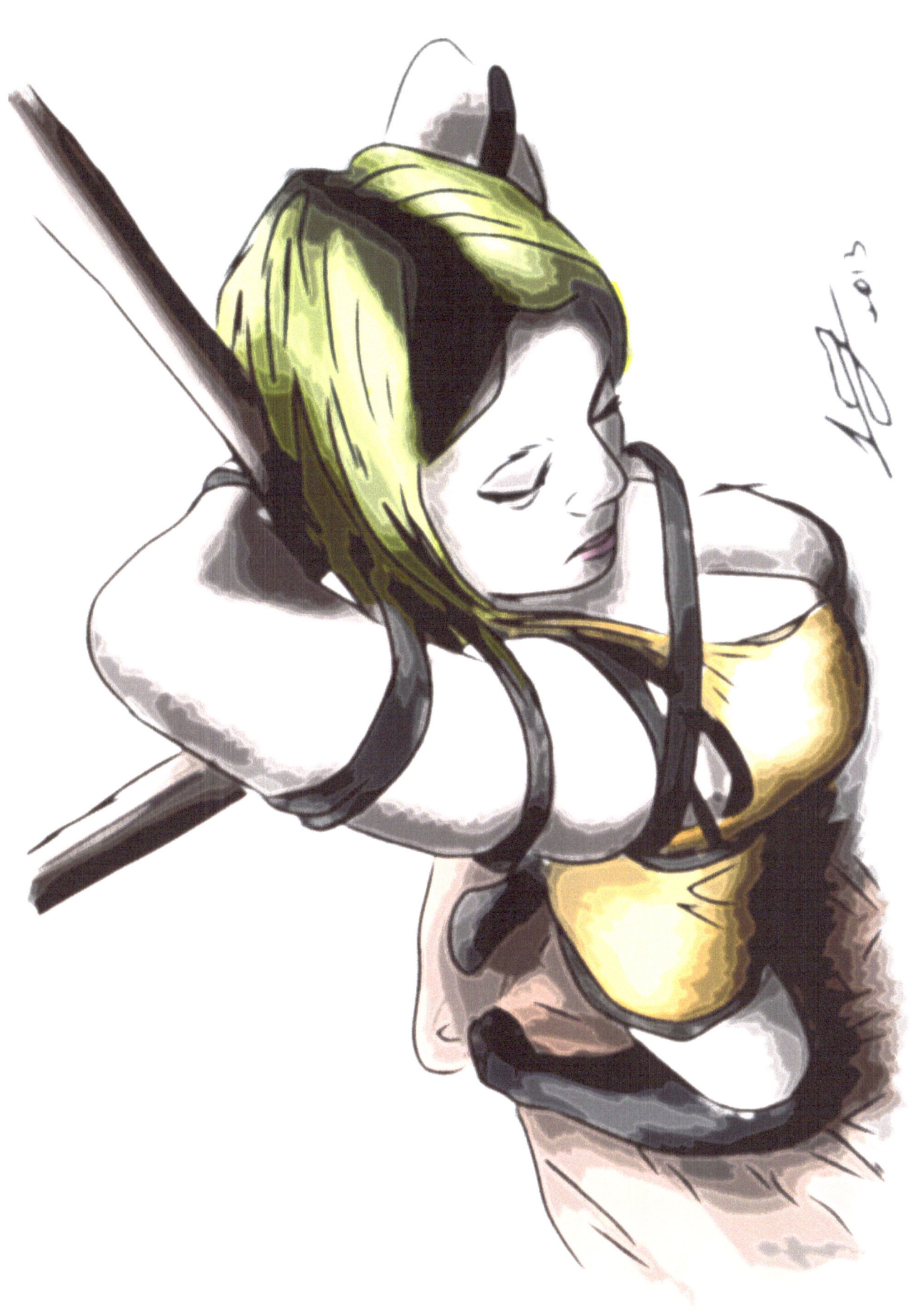

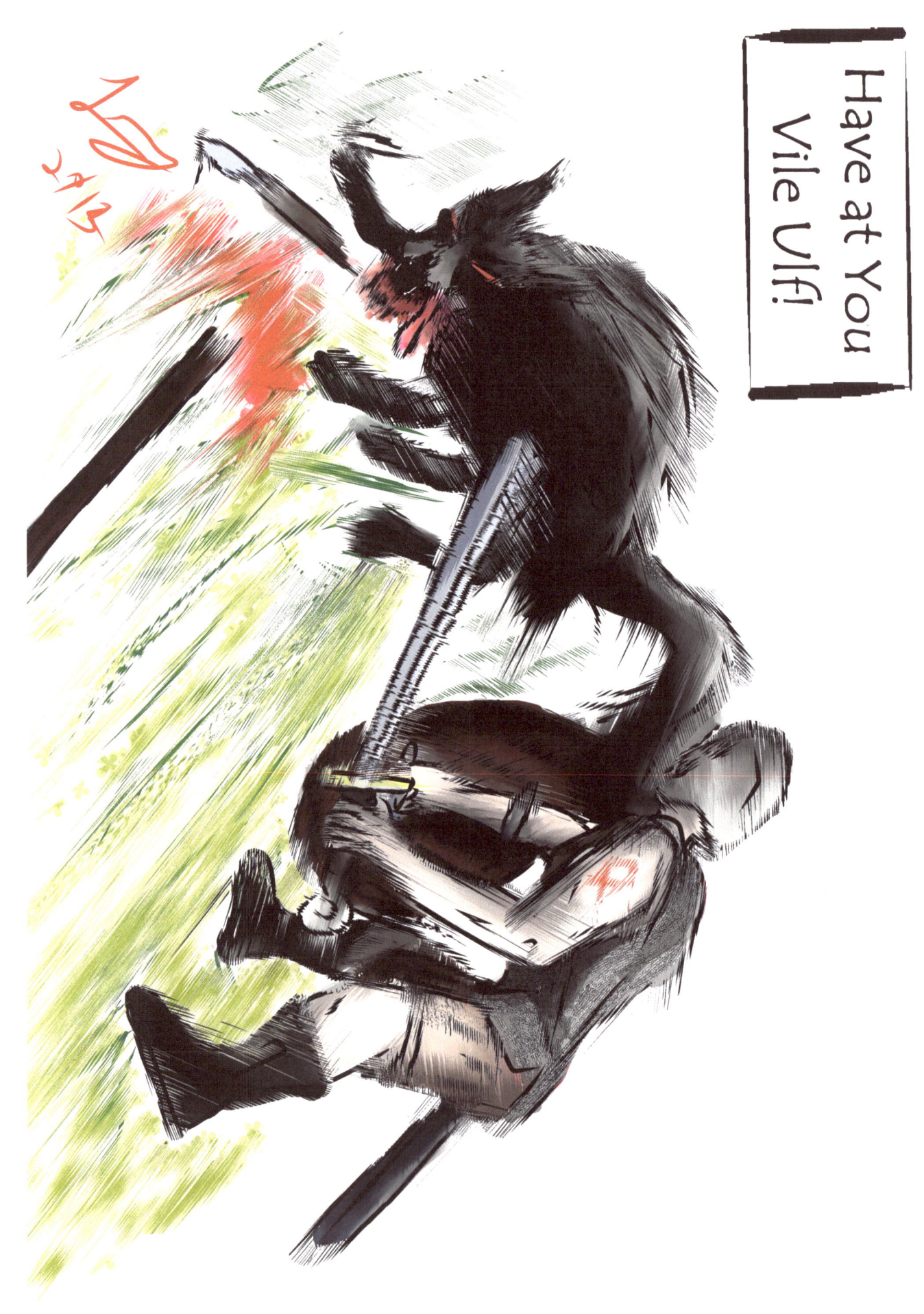

Foamy's Letter to Santa

Character and poem by Jim Mathers
Illustration by Benjamin Long

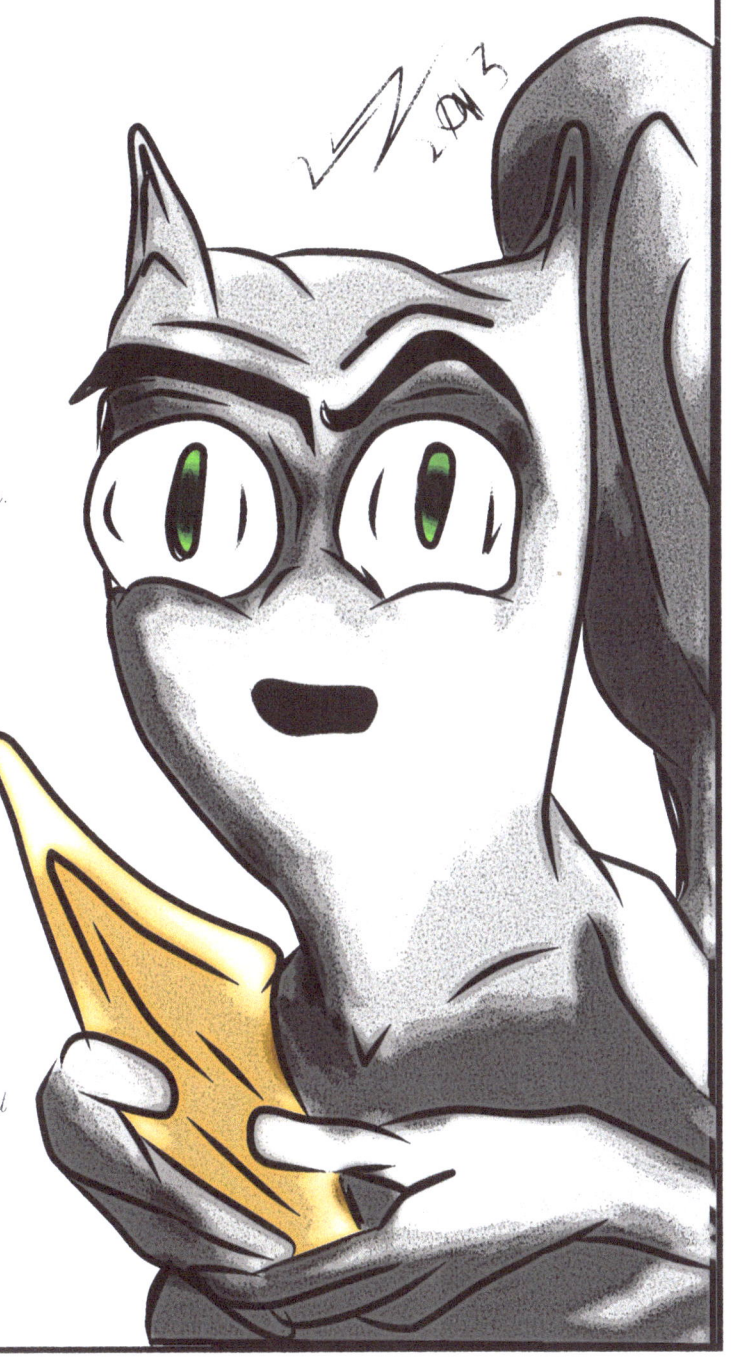

Dear Santa, or guy with the Beard
This letter is from Foamy with Squirrely Cheer.

I would start this letter by asking for stuff
but not this squirrel, I have enough.

This year I ask for a simple request
I know you are busy Santa, but give it your best.

As the years go by we see greater complaints
of singing Icons of Jesus, and statues of saints.

For Christmas I want to celebrate it once true
without liberal douchebags burning Pictures of you…

They rant "I don't like Christmas," but I don't see why
We get to eat Ham, Turkey, and get presents and pie.

I don't like Turkey of course, but gifts for the masses
How is that wrong?

People that hate Christmas scream "Tolerance for all!"
But have intolerance, when it is at their door.

They whine and complain about Christmas in town
When menorahs and Kwanza are on the school grounds.

It is a known double standard, known wide and true
There's a solution, especially for you.

You know you give coal to those who are naughty,
But I have something that is a little more sporty.

I would lace little candies with minty fresh poison
and give them to morons so they may enjoy them.

Is there a better way to put this issue to rest?
Than to send them minty fresh candies of death?

So forget all the toys and the crap on my wishlist,
I just want to have an enjoyable Christmas

Of course if you can find room on your sleigh for a treat
Cream Cheese is good, and bagels are neat…

That's all from Foamy and I will see you soon,
make sure you bring candies I have morons here too!

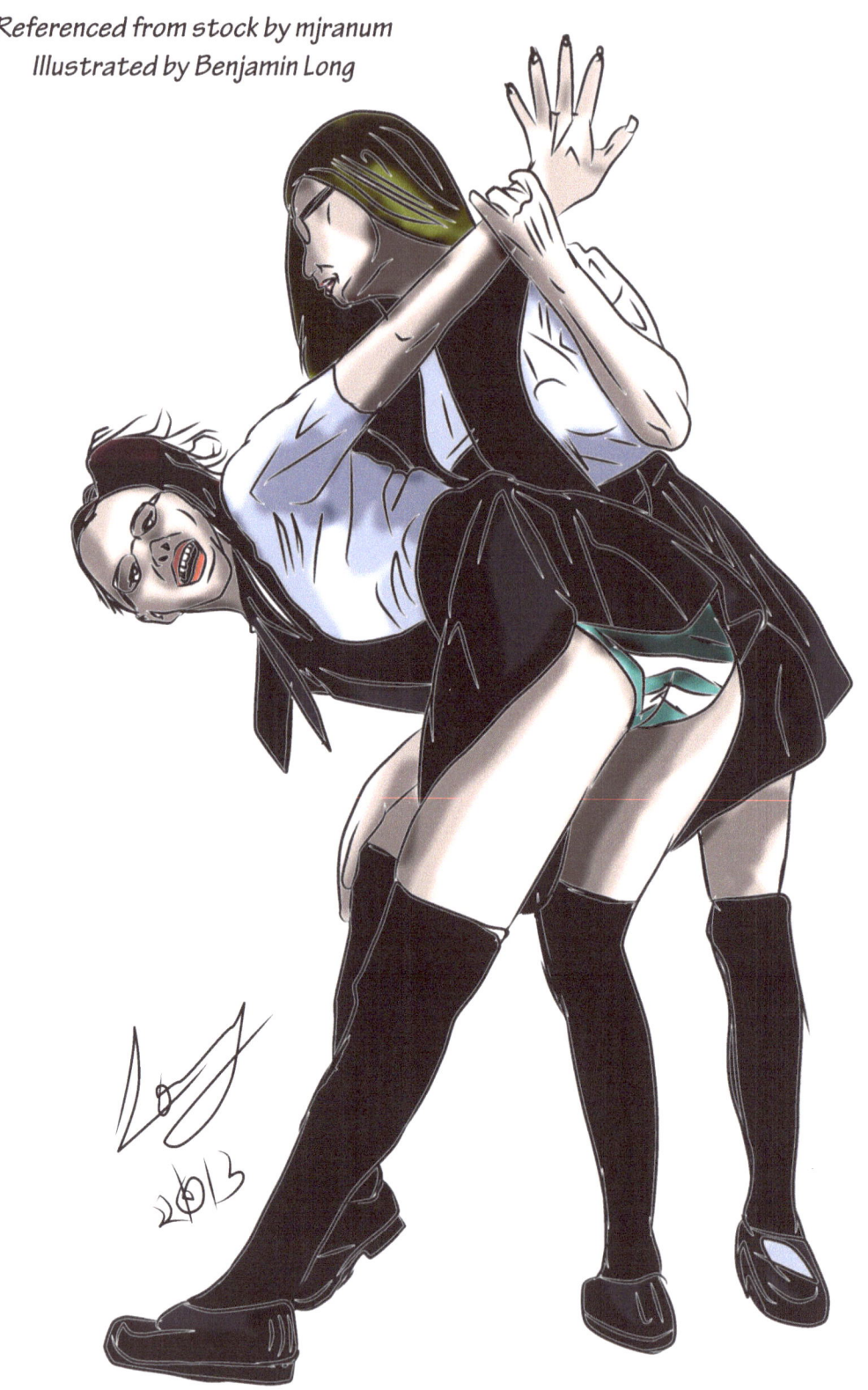

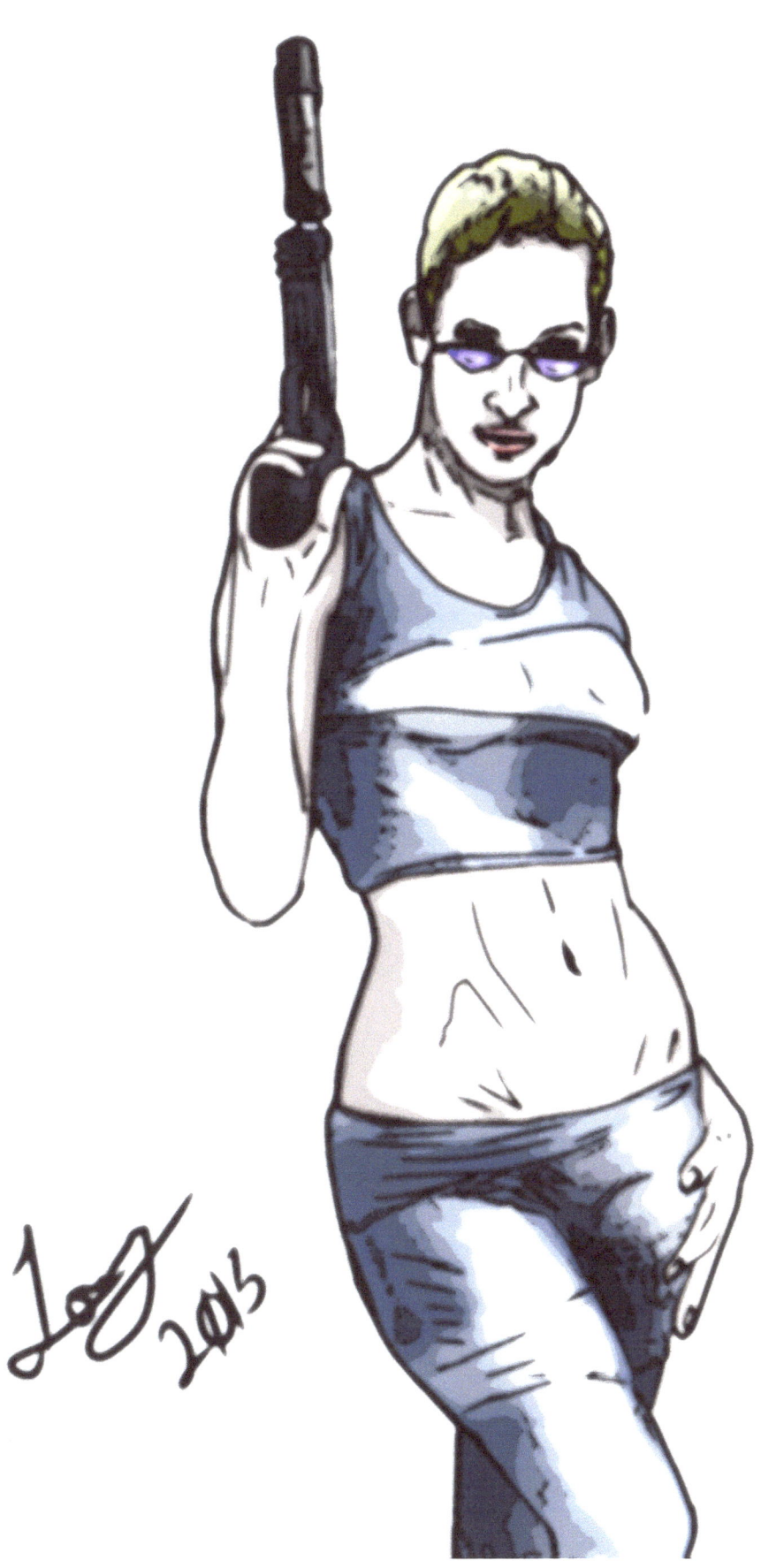

Blue Tit

Referenced from photo by freyaphotos
Illustrated by Benjamin Long

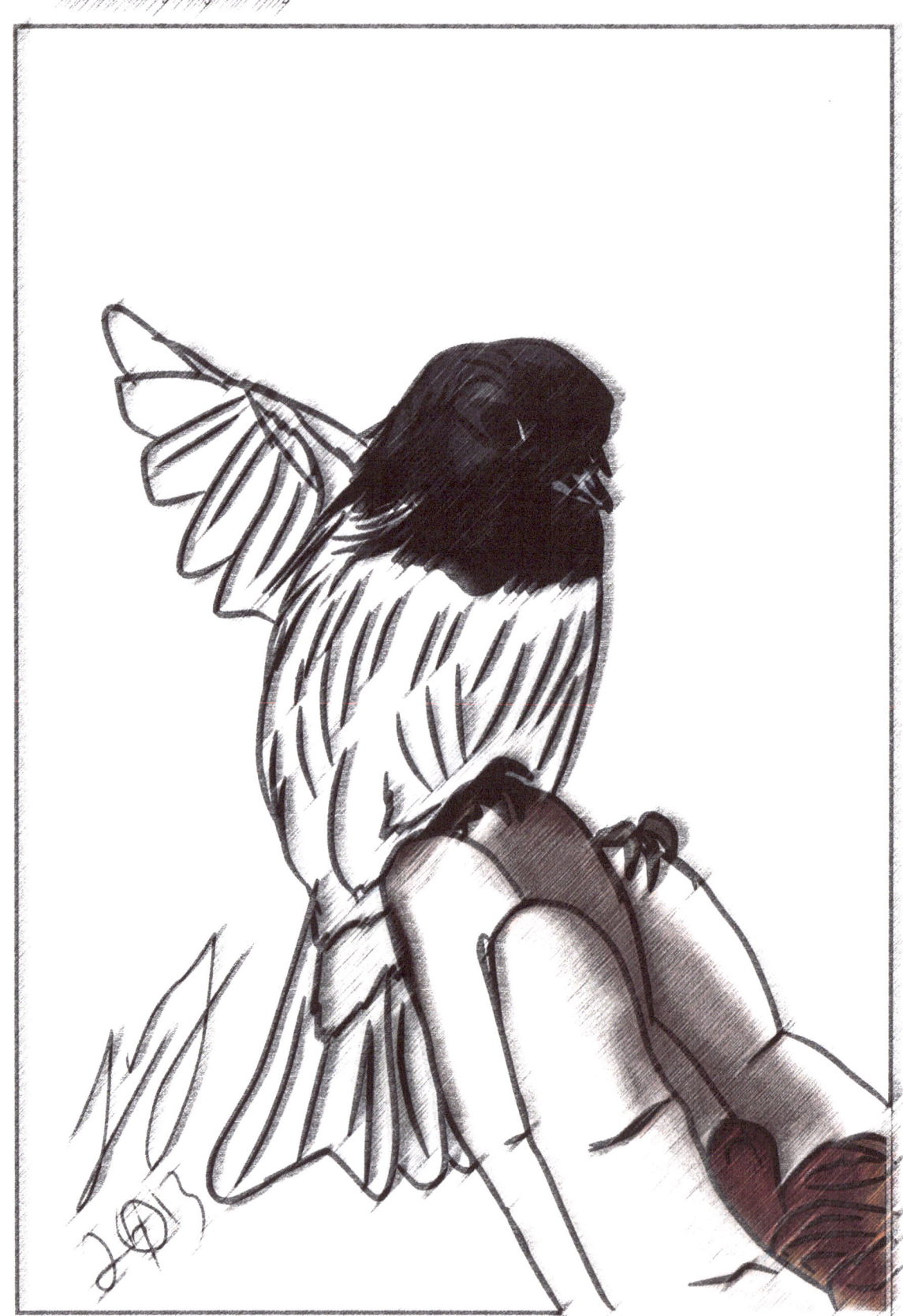

"Free Flight"

Referenced from a Stock Photo by Mjranum
Illustrated by BenjaminLong

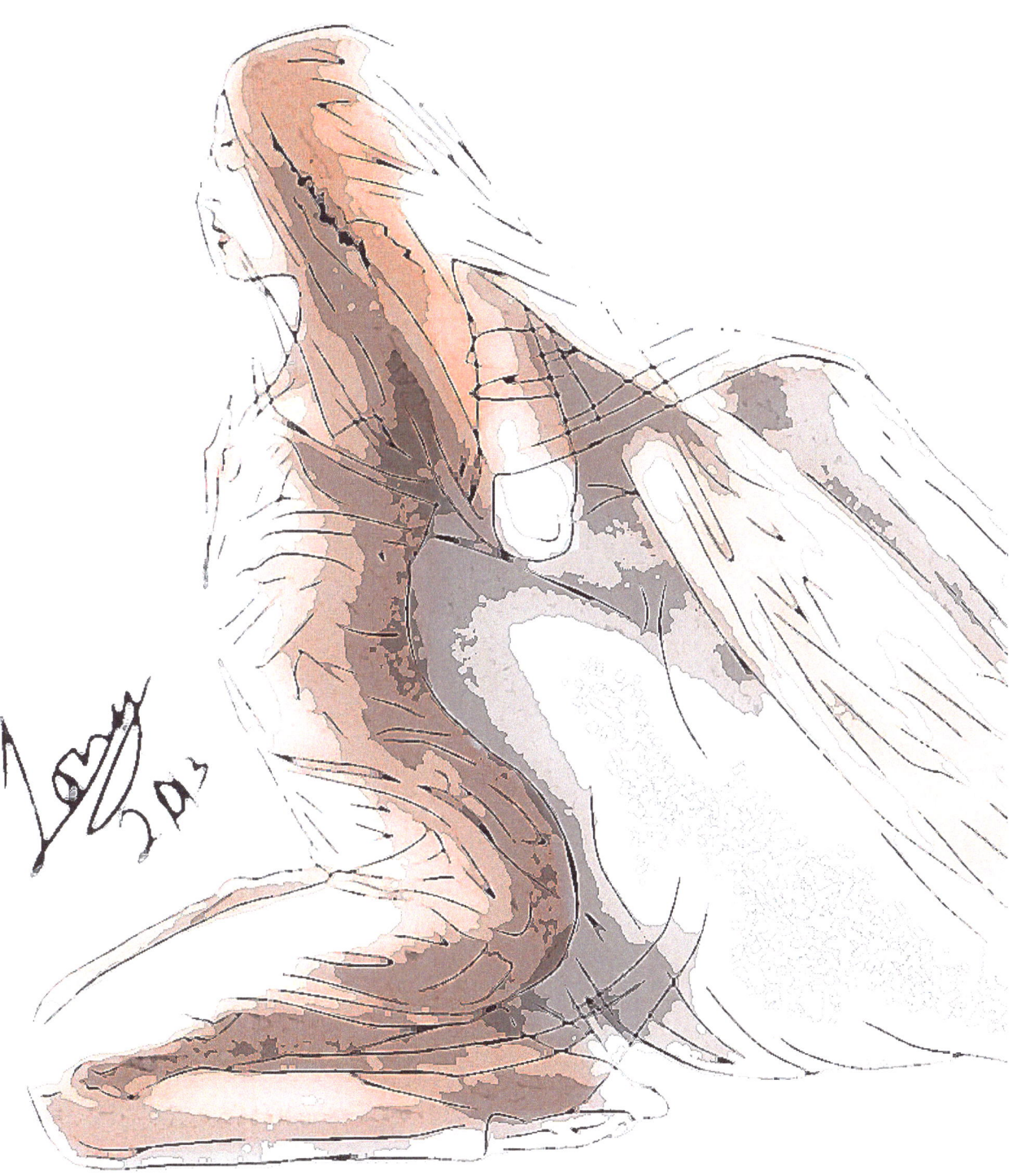

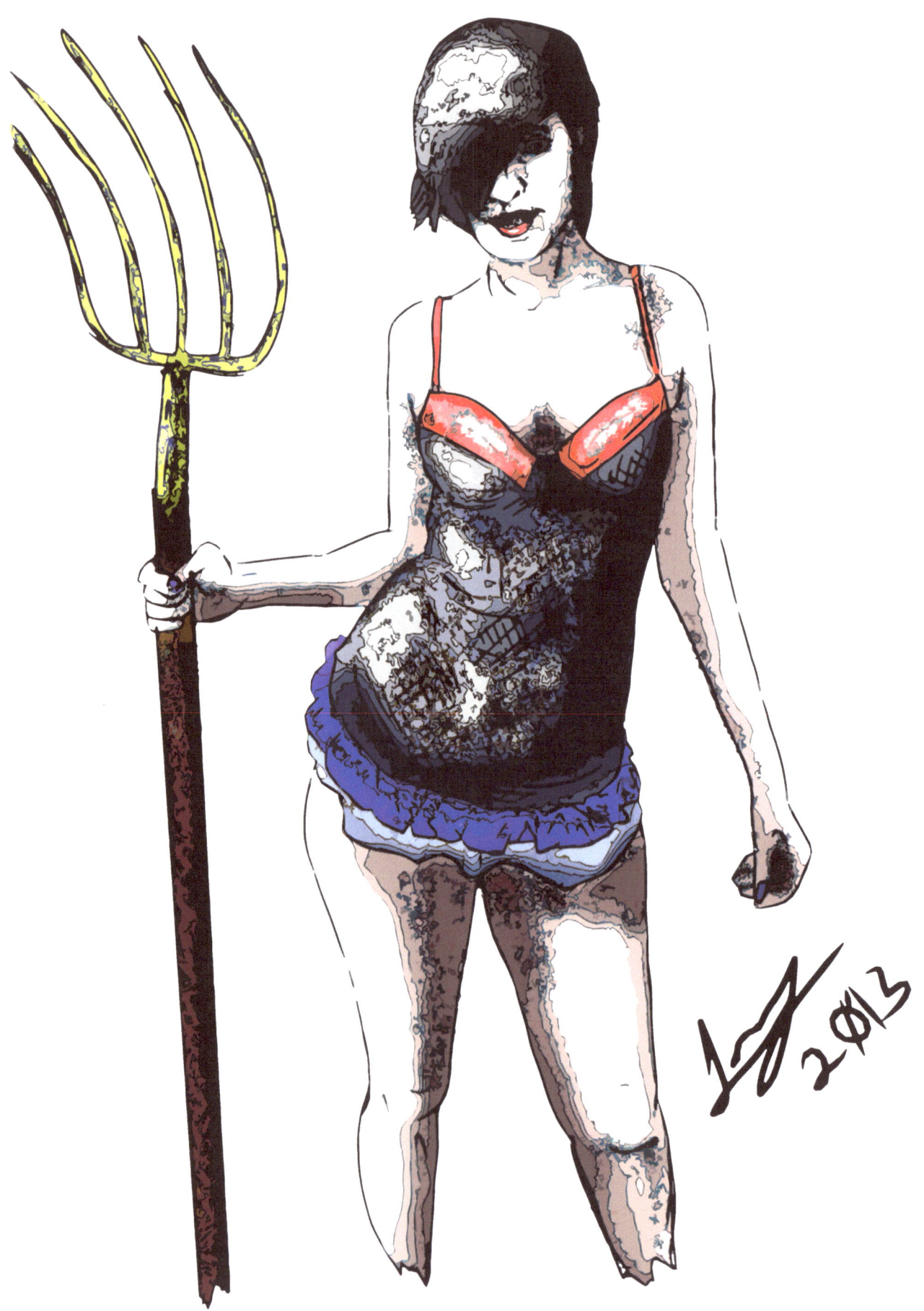

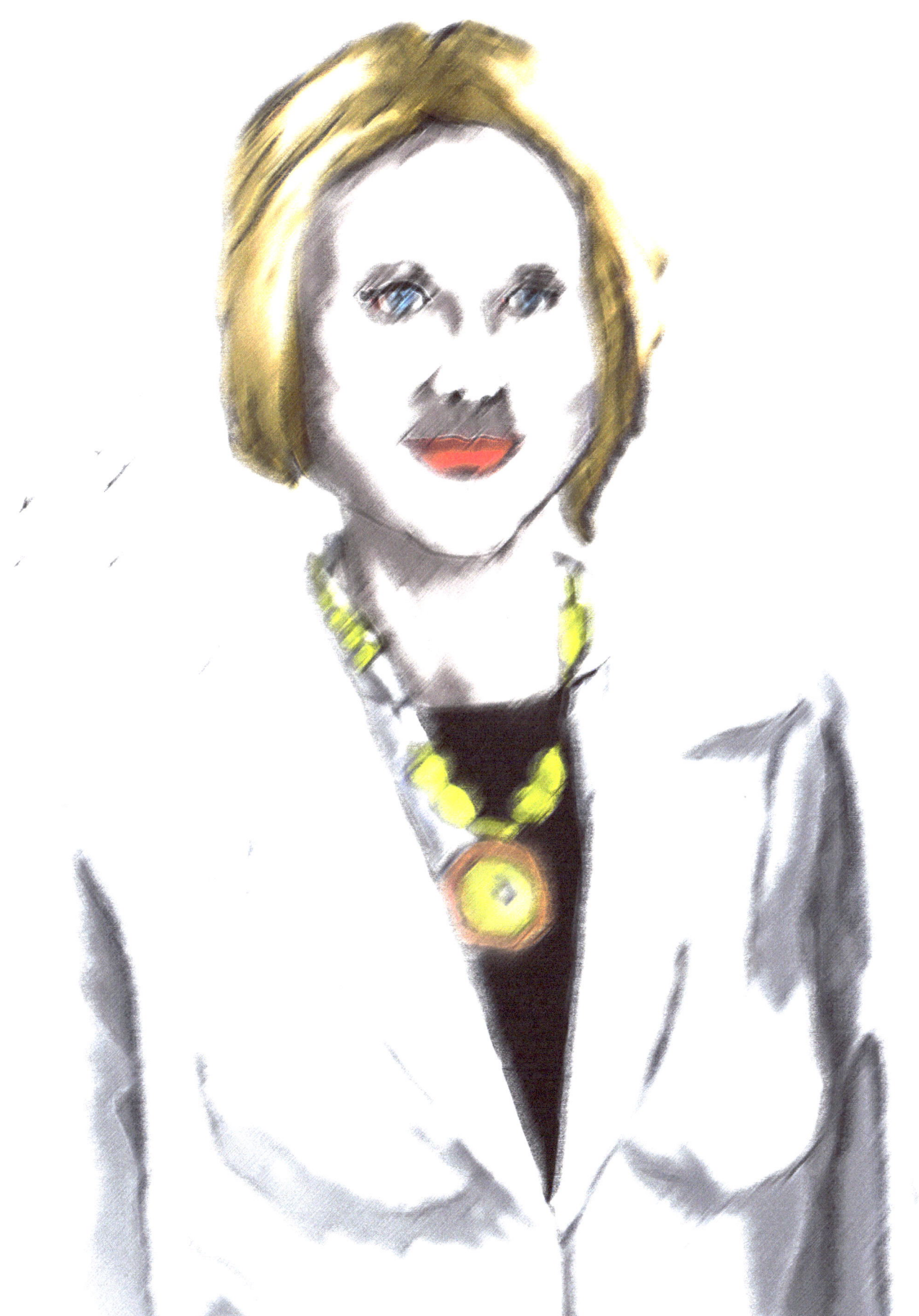

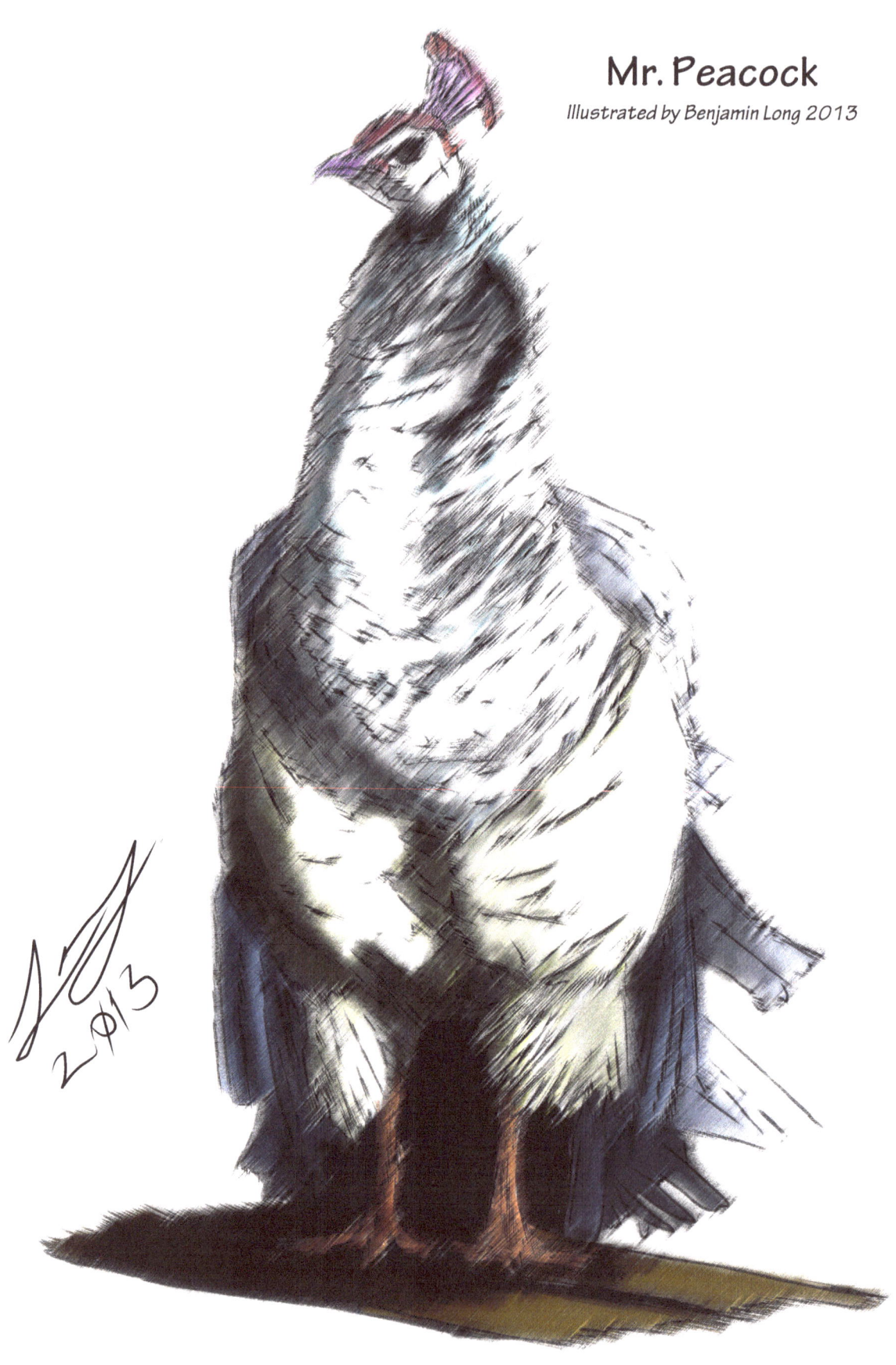

Mr. Peacock
Illustrated by Benjamin Long 2013

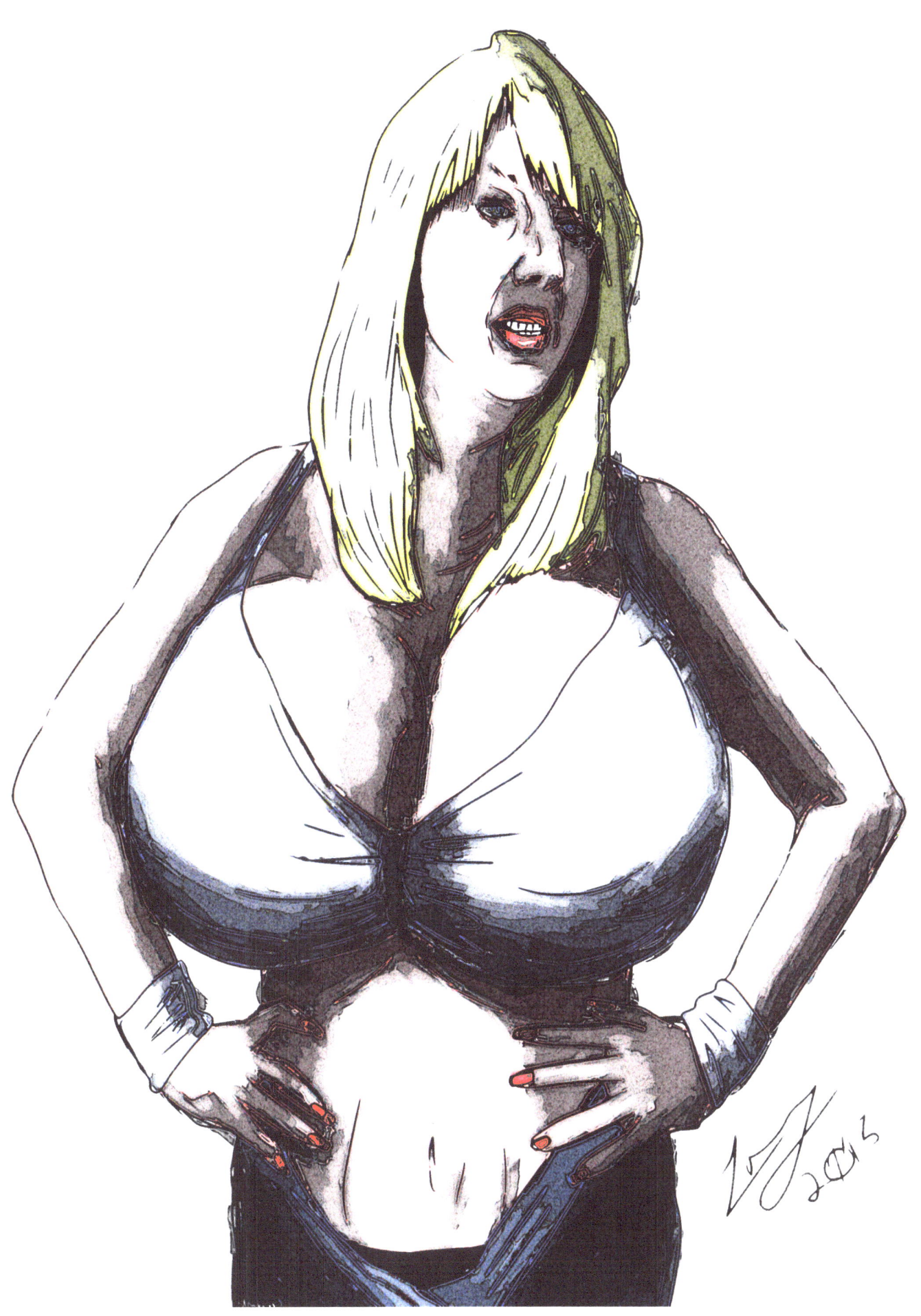

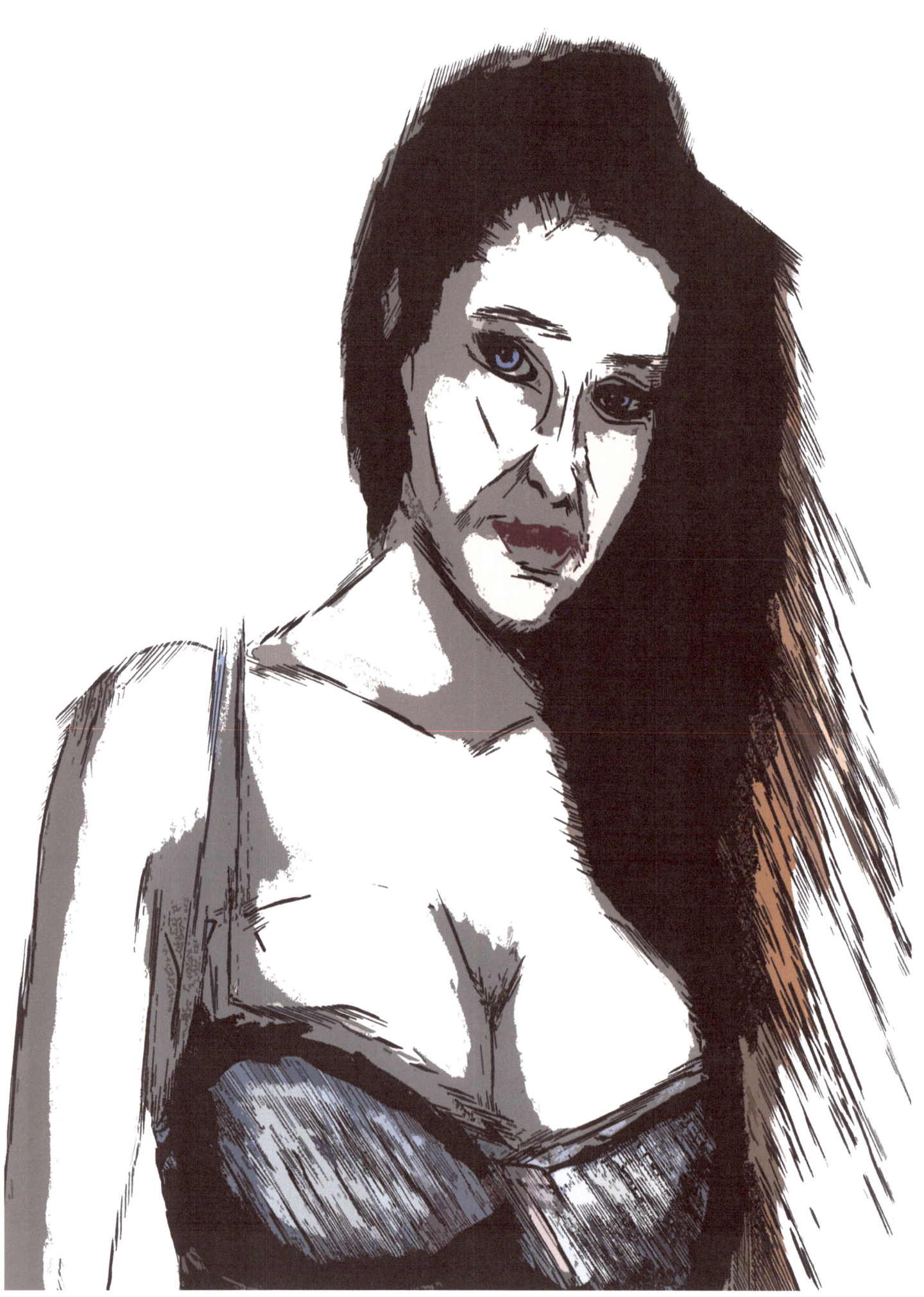

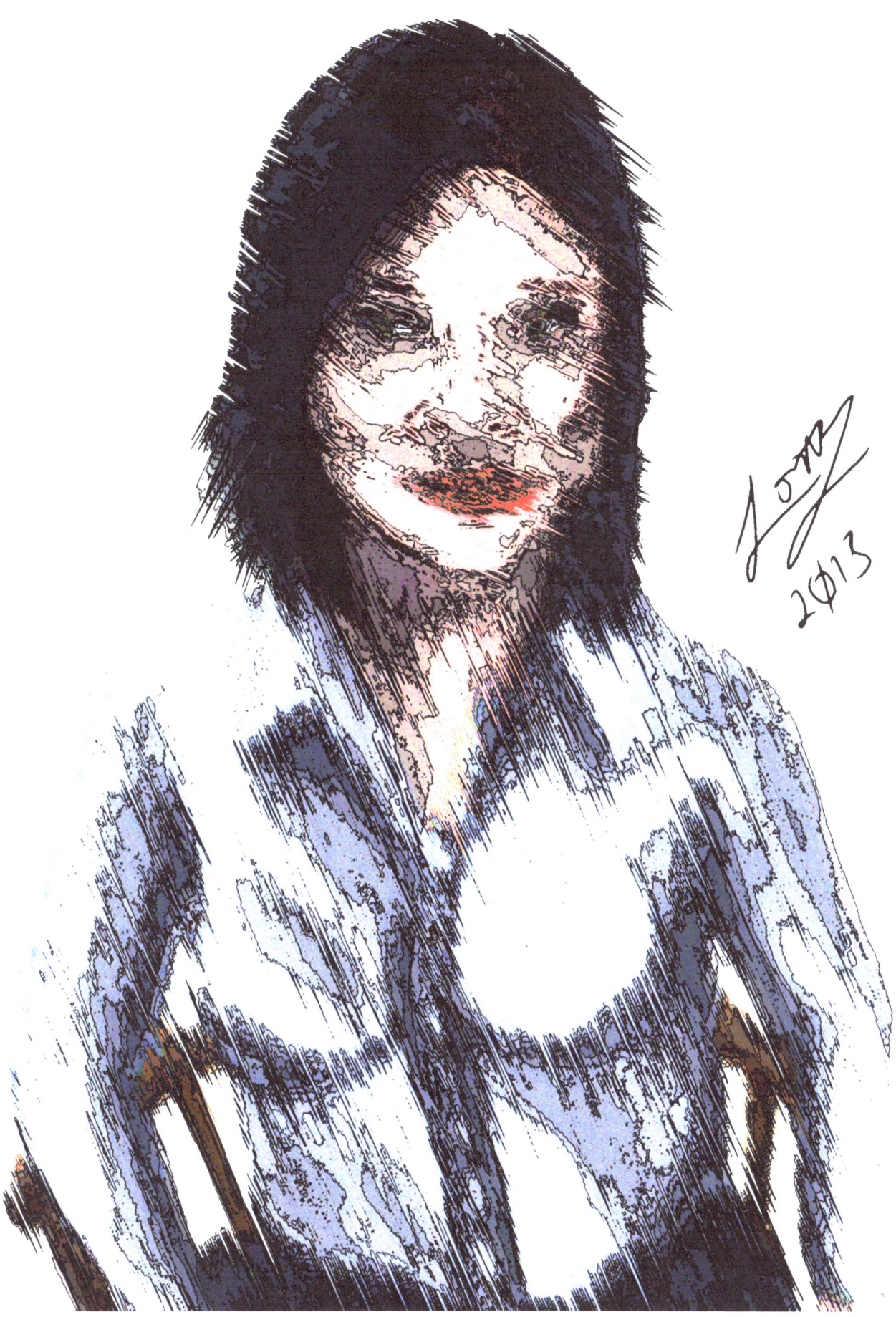

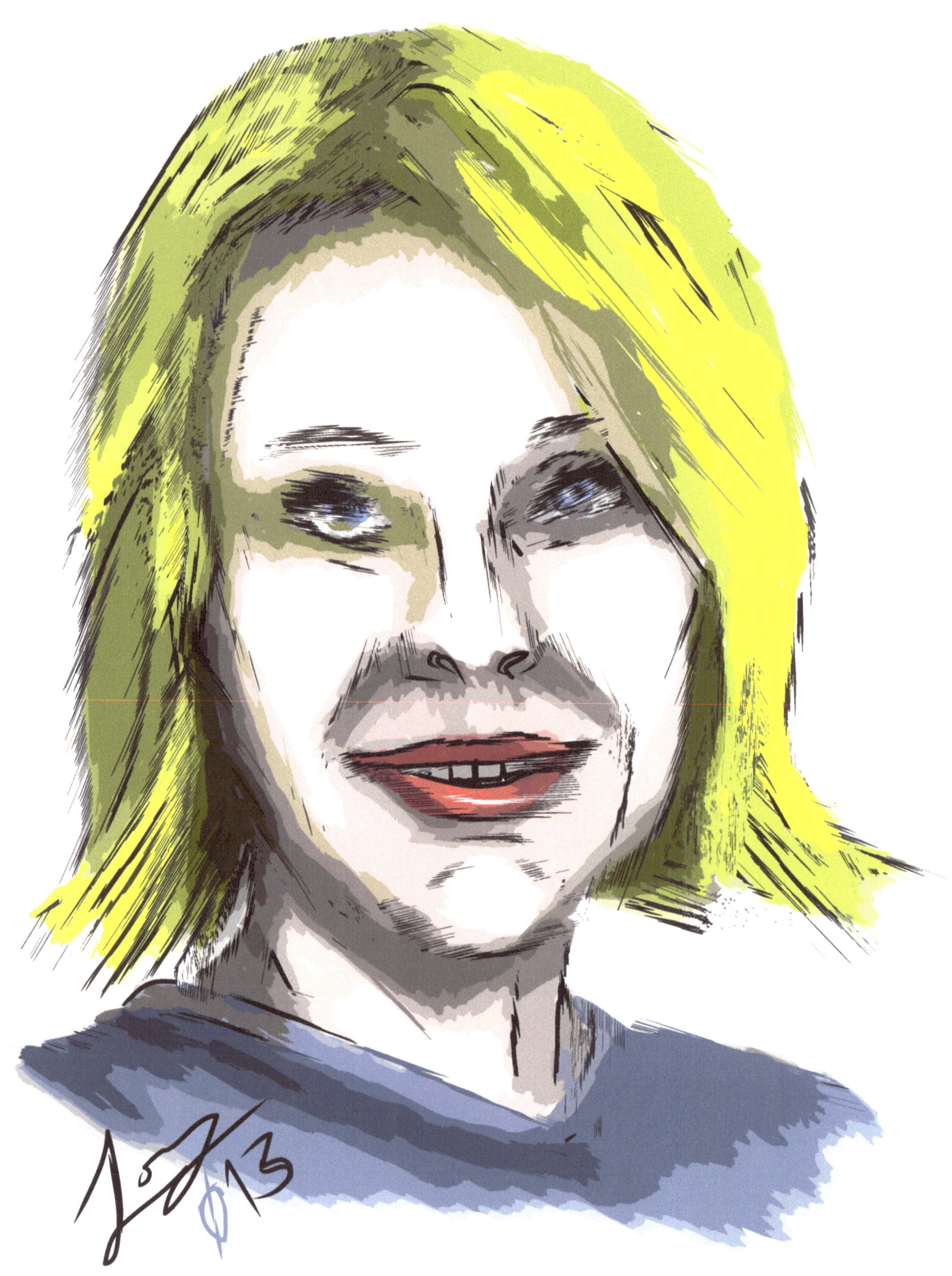

Education or Re-Education?

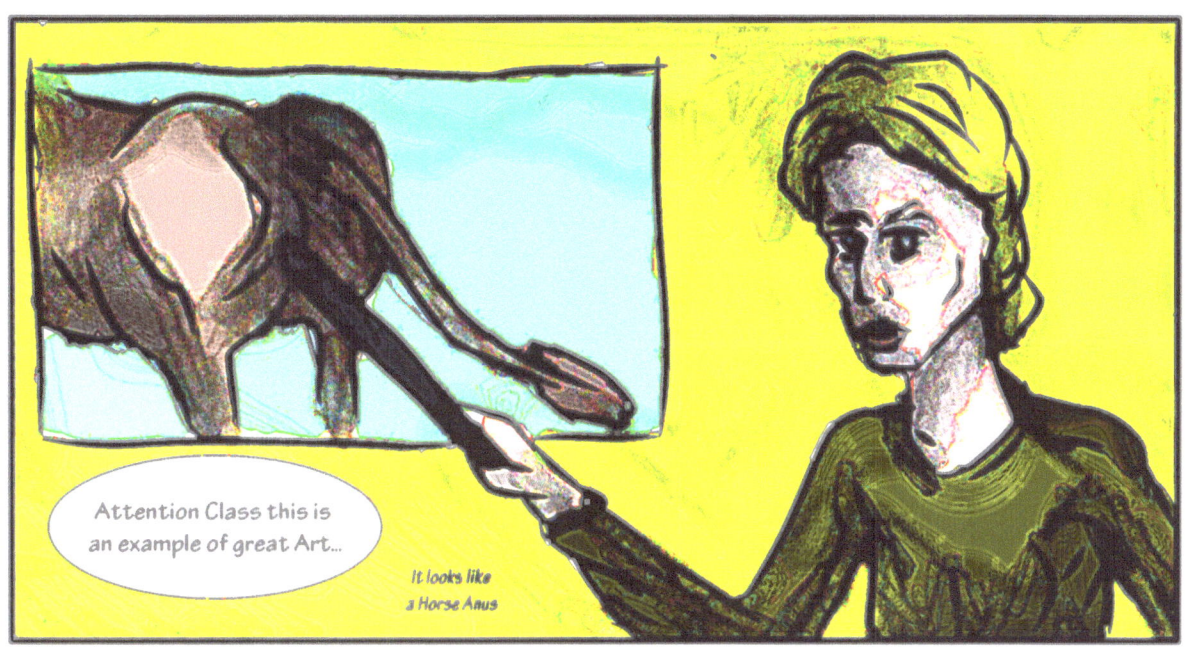
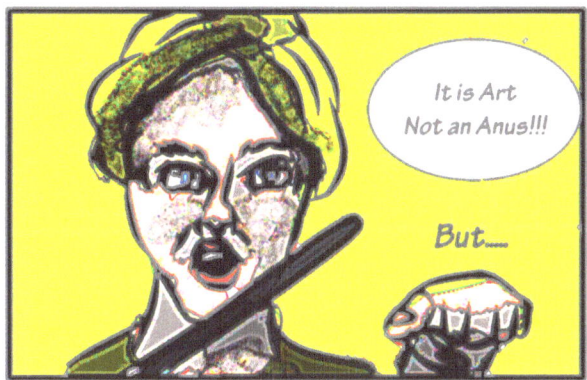
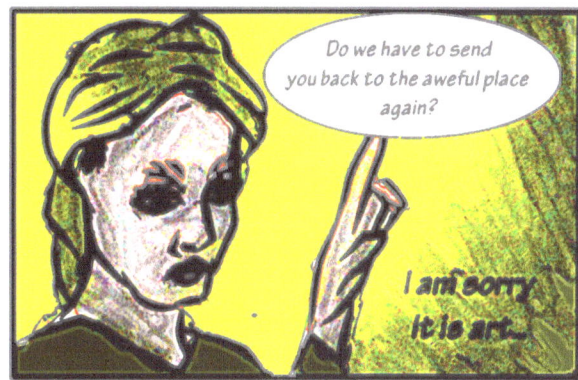
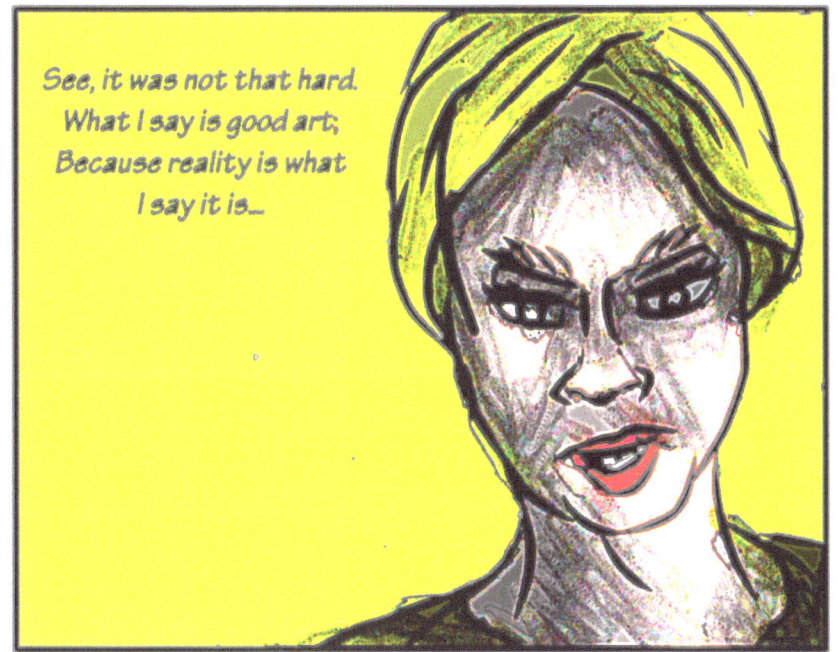

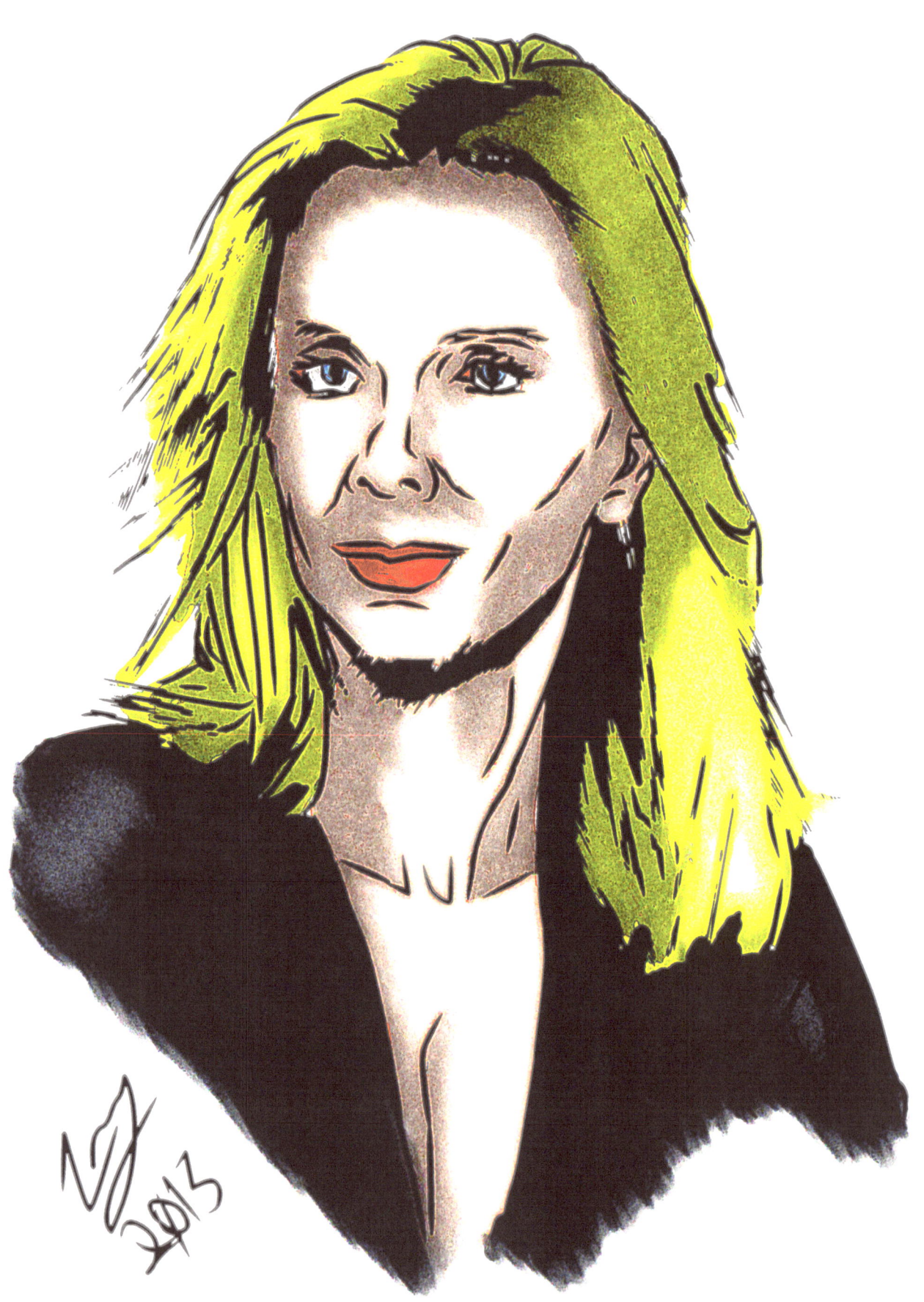

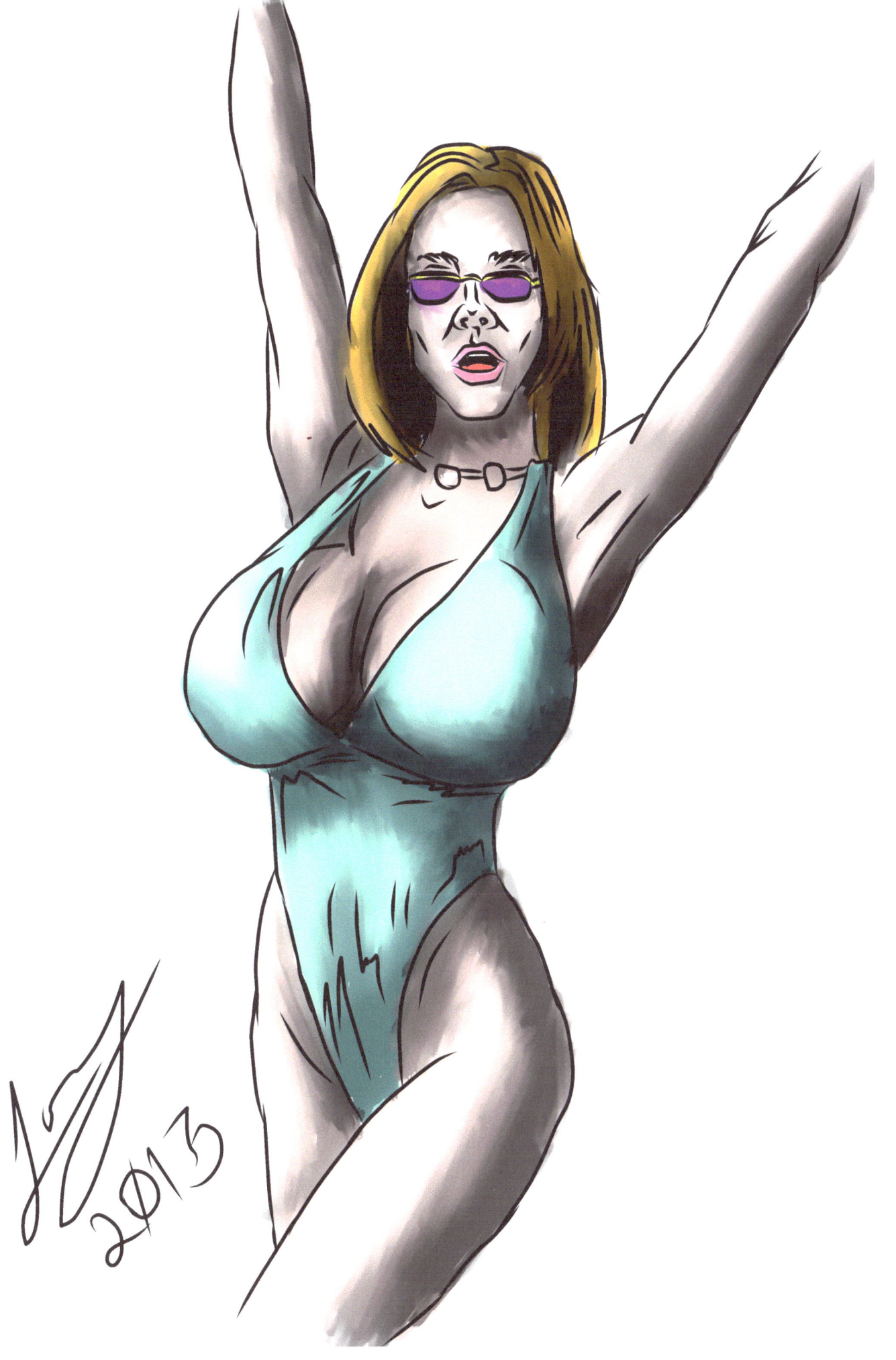

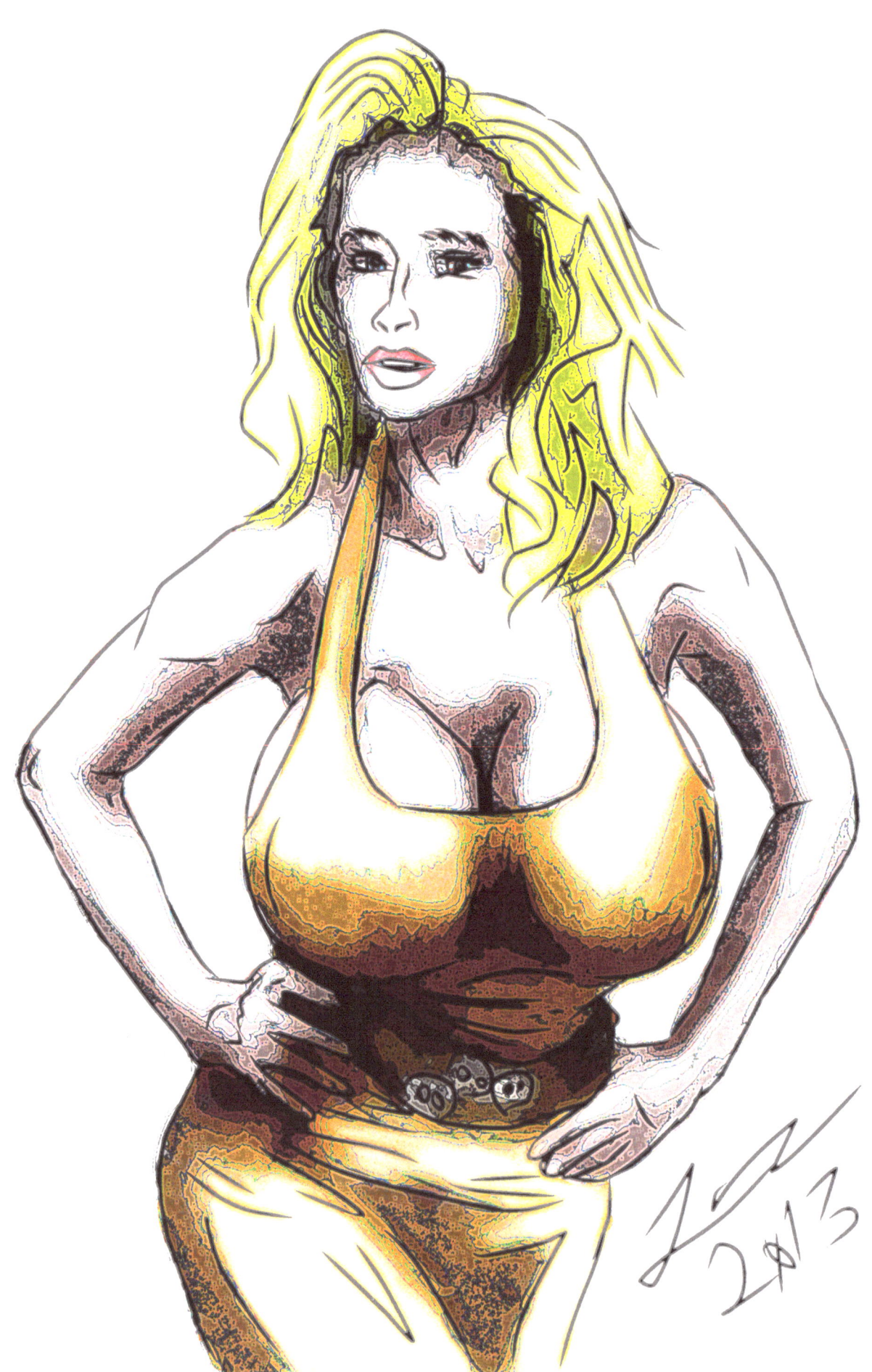

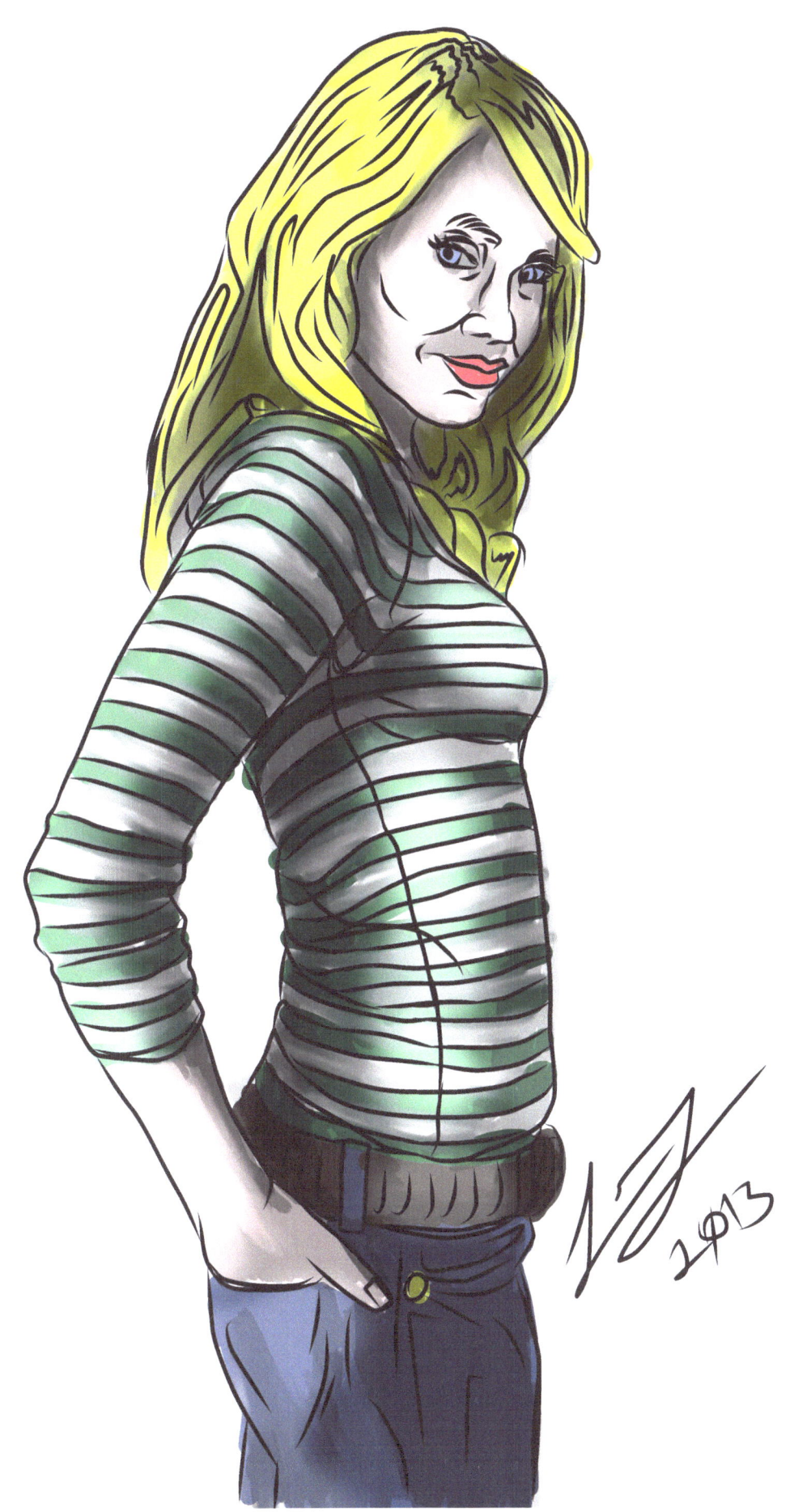

Heathen Art LLC

Benjamin Long, **Illustrator**

The pieces of artwork contained within are the property of Heathen art and Benjamin R Long. No image may be duplicated in part or whole without written permission of Benjamin Long.

Copyrighted images are protected under Title 17 of the USC and traditional copyright applies and duplications must be made in accordance with US law regarding the "Fair use " clause.

Benjamin Long may be contacted on the following Forums:

E-Mail: wiking88142001@yahoo.com

Skype: whitewolfheathen

http://whitewolfheathen.deviantart.com/

Copyright © 2013 (Benjamin Long): All rights reserved.

Commission rates :

Rough Sketch $8 USD

Digital Drawing/Painting $25 USD

Traditional Drawing/Painting on Canvas Panel 8x10 $35 USD

Traditional Drawing/Painting on Canvas Panel 16x20 $80 USD

www.ingramcontent.com/pod-product-compliance
Lightning Source LLC
Chambersburg PA
CBHW051108180526
45172CB00002B/828